Faces of Freedom Summer

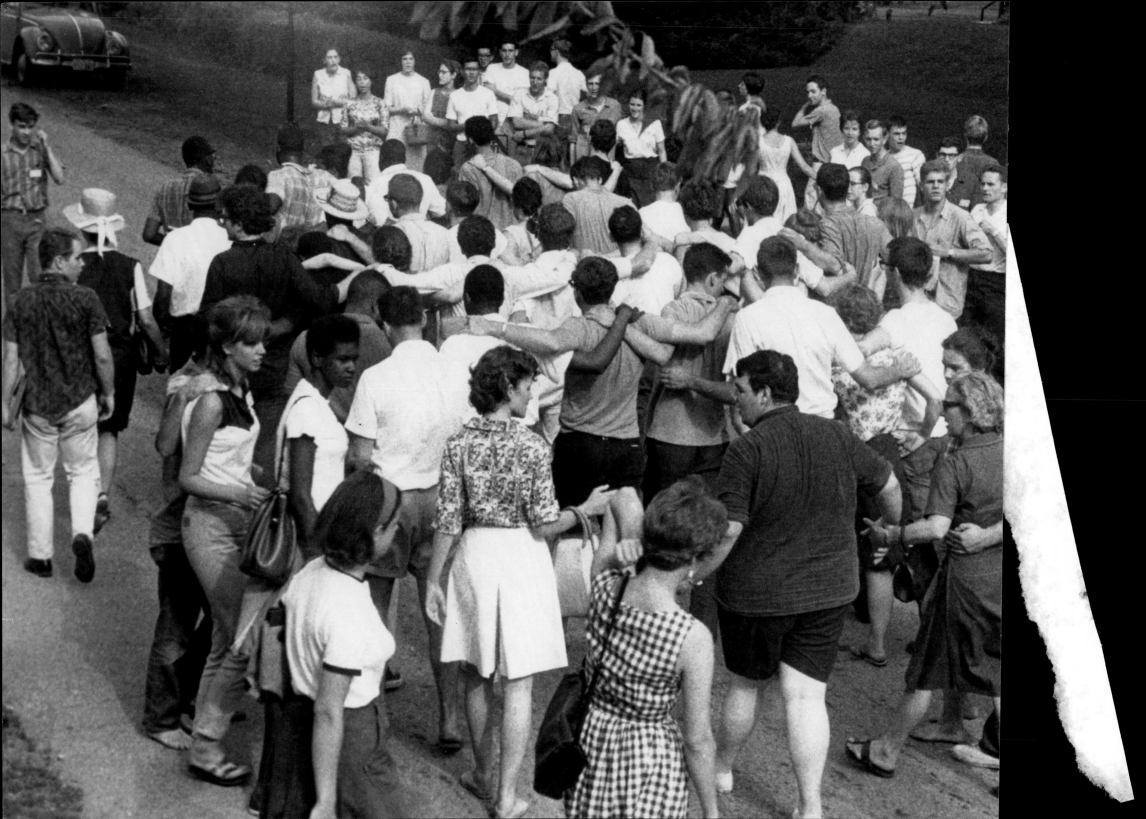

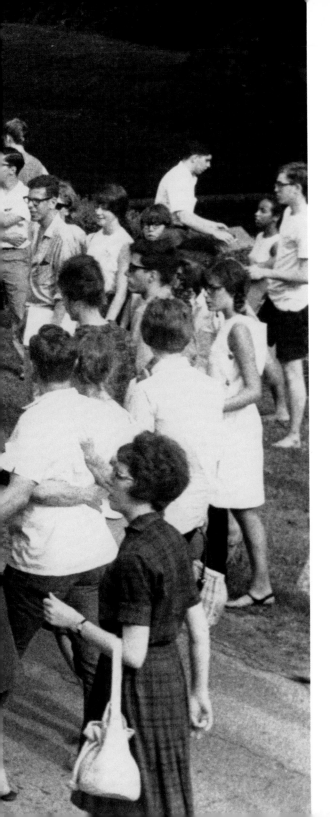

Photographs by
HERBERT RANDALL

Faces of Freedom Summer

Text by
BOBS M. TUSA

Foreword by
VICTORIA JACKSON GRAY ADAMS
and CECIL GRAY

THE UNIVERSITY OF ALABAMA PRESS
Tuscaloosa and London

9 8 7 6 5 4 3 2 1 . 09 08 07 06 05 04 03 02 01

Designer: Michele Myatt Quinn

Typefaces: Stone Sans and Stone Serif

Gratitude is expressed to The University of Southern Mississippi for its generous financial contribution to the publication of this book.

Thanks to Diane Ross of The University of Southern Mississippi for her assistance with the photographs.

∞

The paper on which this book is printed meets the minimum requirements of American National Standard for Information Science–Permanence of Paper for Printed Library Materials, ANSI Z39.48-1984.

Library of Congress Cataloging-in-Publication Data

Randall, Herbert, 1936–

 Faces of Freedom Summer / photographs by Herbert Randall; text by Bobs M. Tusa; foreword by Victoria Jackson Gray Adams and Cecil Gray.

 p. cm.

Includes bibliographical references.

 ISBN 0-8173-1056-8 (alk.paper)

 1. Mississippi Freedom Project—Pictorial works. 2. Civil rights workers—Mississippi—Hattiesburg—Pictorial works. 3. Civil rights movements—Mississippi—History—20th Century—Pictorial works. 4. Afro-Americans—Civil rights—Mississippi—History—20th Century —Pictorial works. 5. Hattiesburg (Miss.)—History—20th Century— Pictorial works. 6. Afro-Americans—Suffrage—Mississippi—History— 20th Century. 7. Afro-Americans—Civil rights—Mississippi—History —20th Century 8. Mississippi—Race relations. I. Tusa, Bobs M. II. Title.

 E185.93.M6 R36 2001

 976.2'18—dc21 00-009858

British Library Cataloguing-in-Publication Data available

To Sandy Leigh

SNCC field secretary and director of the COFO project
in Hattiesburg, Mississippi, Freedom Summer 1964

CONTENTS

FOREWORD

"One picture is worth ten thousand words." I don't know who first made this statement, but I agree with it. There are simply not enough words to describe the period in our history that is recorded by the pictures in this book.

I was involved in this epic-making time, present for many of the events documented in these pages. Viewing these pictures brings back feelings that I thought I had done with, memories that I no longer visit even in my dreams. It is good and healthy for me to recall these memories now. When I turn on the radio and hear about the resurgence of overt activities by hate groups—both the old traditional ones (e.g., the Ku Klux Klan) and the new ones (e.g., the Skin Heads)—I realize that, however much the hard work and sacrifices of the modern civil rights movement humanized American society, much still remains to be done. The modern civil rights movement associated with the 1960s *was not in vain,* yet it did not eradicate from our society the evils of racism and sexism. While we activists made the United States more of an open society than it has ever been in its history, our vision and desire for the beloved community did not reach into all sectors of American society. "Freedom," it has been said, "is a constant struggle, a work of eternal vigilance." As this statement implies, evil lurks in the hearts and minds of humankind, always with us, always waiting in the wings for a moment when it can reappear on the stage of life.

How, then, do we overcome? The answer, summed up in one word, is Sankofa ("San-koh-fah"), an Akan/West African term meaning to "return to the past, pick up the best parts, bring them into the present, and utilize them to make the present good, and utilize them to build a great and glorious future." We can, indeed we must, continue to revisit, rehearse, recall, record, exhibit, and reexamine those moments when there arose among us a people of peace that with authenticity and integrity sought liberty and justice for *all.*

Truly there was such a time, and there was such a people, as this pictorial work affirms. And if such a people was once, then it still is among us. Yet this people may become aware of itself only when individuals are confronted with visible evidence—such as the evidence contained in the pictures of Herbert Randall. The evidence of these pictures confirms, affirms, validates, and reiterates the yearning for an orderly, peaceful and just world.

Thanks, Dr. Tusa, for all you have done to preserve and present this history to the people of the present age.

Thanks, Mr. Randall, for sharing this evidence of such a time and such people in our past.

Victoria Jackson Gray Adams
Cecil C. Gray

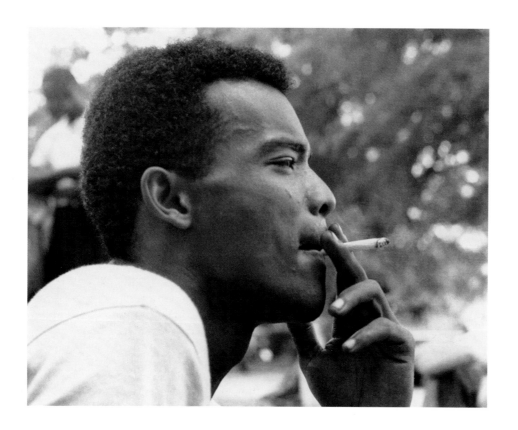

Herbert Randall in Hattiesburg, Mississippi, Freedom Summer 1964

INTRODUCTION

They came to Mississippi from everywhere that summer of 1964 to join with local black citizens in a national effort to make American democracy work. John Lewis, chairman of the Student Nonviolent Coordinating Committee (SNCC), had said, "If we can crack Mississippi, we will likely be able to crack [racial segregation] in the rest of the country."[1] They would call it Mississippi Freedom Summer.

One of those who came was Herbert Eugene Randall, Jr., an African and Native American from New York City. Randall had just been awarded the prestigious John Hay Whitney Fellowship for Creative Photography. A chance meeting in New York City with SNCC field secretary Sandy Leigh, director of the Freedom Summer project in Hattiesburg, led to Randall spending two months during the summer of 1964 photographing Freedom Summer activities in Hattiesburg, the largest Freedom Summer site.

The result was 1,759 negatives, which Randall generously donated in 1998 to the Archives of the University of Southern Mississippi (USM), located in Hattiesburg. Most of these photographs had never been seen until 1999, when they were exhibited under the auspices of the University of Southern Mississippi Museum of Art in association with the USM Libraries. The exhibit "Faces of Freedom Summer: The Photographs of Herbert Randall," reproduced in this book, encompasses 102 images. A symposium of Freedom Summer activists was held on the USM campus, and receptions were given by St. John United Methodist Church and Mt. Zion Baptist Church. The exhibit, mounted with financial assistance from the National Endowment for the Humanities through the Mississippi Humanities Council, lasted from June 7 until October 31, 1999, afterward touring the United States.

In 1964, the Freedom Summer volunteers who came into Mississippi were dubbed "outside agitators" by their opponents. The term, intended to be pejorative, was nonetheless very accurate. The activists did come from outside, and their purpose was to agitate, peacefully and nonviolently, for change. Welcoming the volunteers and embracing their good intentions on faith were hundreds of courageous black residents, who today are deservedly regarded as local heroes. Their efforts were organized and facilitated by the college-age men and women of SNCC.

Working together, the volunteers, the local activists, and SNCC changed not just Hattiesburg and the state of Mississippi but the entire nation. It is our extraordinary good fortune that artist Herbert Randall preserved their efforts during Freedom Summer on film.

The Photographer

Herbert Eugene Randall, Jr., was born on Long Island, New York, in 1936. After studying photography with Harold

Feinstein in 1957, Randall worked as a freelance photographer from 1958 to 1966. His work was distributed by the Associated Press, United Press International, and Black Star; was seen on television, including the CBS, NET, and WPIX stations; and appeared in American and foreign magazines, books, and brochures. Randall was one of the founders of the Kamoinge Workshop in New York City in 1963.

The John Hay Whitney Fellowship for Creative Photography that Randall was awarded in 1964 was intended to enable him to spend a year creating a photographic essay on black life. This was one of the John Hay Whitney Foundation's "Opportunity Fellowships," 953 of which were awarded between 1950 and the end of the program in 1971 for graduate or professional study and study in the arts.

The recipients were principally American Indians, blacks, Mexican Americans, impoverished mountain whites, Puerto Ricans, students from the Pacific Island Trust Territories, and . . . Japanese and Chinese living in this country. The recipients of Opportunity Fellowships were selected because they were able people who encountered unusual barriers to professional and graduate education by the conditions of their lives. The individuals selected were principally people interested in the study of the humanities, including the social sciences, and in professions significantly concerned with human problems and human values.[2]

In 1964–1965, fifty-six Opportunity Fellowships were awarded for a total of $127,500, the average award being about $2,500. Ten recipients were residents of New York City. Herbert Randall, who was then living in the Bronx, was one of them.[3]

When Herbert Randall met SNCC field secretary Sandy Leigh in New York City in late 1963 or early 1964, everyone was talking about going to Mississippi to participate in SNCC's Summer Project. At the time Randall was not sure that he wanted to go. He had never been farther south than Washington, D.C., and Mississippi had a negative reputation among people of color. But Randall and Leigh hit it off, and "Sandy had a way of making things seem both logical & as if they would be a lark."[4]

Randall agreed to go, packed up his cameras, and headed first to the SNCC Freedom Summer orientation session held the last week of June at Western College for Women in Oxford, Ohio. Then, covered with a blanket during daylight, Randall rode into Mississippi in the backseat of a car full of white civil rights workers. While he slept the sleep of exhaustion and stress in the home of his Hattiesburg host, the car, a white Saab parked in front of SNCC's headquarters in the black section of town, was shot at by a white man from a pickup truck. So Randall's first photographs of Freedom Summer in Hattiesburg were of the damaged automobile and the worry on the faces of the volunteers, who had already learned in Oxford of the disappearance and probable murder of Michael Schwerner, James Chaney, and Andrew Goodman near Philadelphia, Mississippi.

Whatever concerns Randall may have felt, he stayed in Hattiesburg for the rest of the summer, photographing anything he wanted to record. He was given no specific assignments by Sandy Leigh or by the Freedom Summer organizers. He just went wherever his camera led him. He was generally followed by black children and young people. According to Sheila Michaels, "he & [Freedom School teacher Dick] Landerman always had kids trailing after them. Usually teenagers. They were 'cool' urban guys."

After Freedom Summer, Randall continued to combine

his interests in photography and in young people. Back in New York City, he served as supervisor of photography for the Bedford Stuyvesant Youth in Action organization from 1966 to 1968. He was photographic consultant to the South Bronx Youth Village and also instructor of photography in the Brooklyn Children's Museum from 1968 to 1970. While serving from 1970 to 1974 as coordinator of photography for the New York City Board of Education, a multimedia project, Randall was awarded a Creative Artists Public Service Grant for Photography for 1971–1972. From 1974 to 1983 he was photographic consultant to the National Media Center Foundation.

Herbert Randall's photographic art has appeared in exhibits hosted by the San Francisco Museum of Modern Art, the High Museum of Art in Atlanta, the International Center of Photography, the Danbury Academy of Fine Arts, the University of Texas Art Museum, the Corcoran Gallery in Washington, D.C., and other noted museums. Randall's photographs are represented in the permanent collections of the Metropolitan Museum of Art, the Museum of Modern Art, the IBM Collection, the Charles Rand-Penney Foundation, the International Museum of Photography (George Eastman House), the Library of Congress, the New York Public Library, and the Vassar College Art Gallery.

The Photographs

At the conclusion of Freedom Summer in August 1964, Herbert Randall took the 1,759 negatives that he had shot during those past two months and returned to New York. He put the 35mm negatives in sixteen 5 x 12 inch brown envelopes casually labeled "Beating, Hattiesburg, 7/10/64," etc. When he donated the negatives to the USM Archives in 1998, they remained in the original brown envelopes.

How the gift came about is a tale of preserving history. When I began in 1997 to solicit for the USM Archives gifts of papers and other materials that documented the civil rights movement in Mississippi, I did not have much hope that many such materials remained in private hands. The movement had, after all, taken place over thirty years ago, and its historical significance was recognized at the time.

I persevered, working from word of mouth and from documents like the June 1964 report on the volunteers prepared by spies for the Mississippi State Sovereignty Commission. I compared this report with the Mississippi Community Foundation's list of participants in the 1994 Freedom Summer reunion. Both documents are in the USM Archives, the first in the papers of Governor Paul B. Johnson, Jr., and the second in the collection of Glenda Funchess, formerly a student at a Freedom School in Hattiesburg. One name on both lists was that of SNCC field secretary Sheila Michaels, who had served as project manager of the Freedom Summer office in Hattiesburg. Sheila's reaction to my letter was: "At last! Someone/some institution asking for our memoirs! . . . I have always been surprised (really!) at how little interest we actually stirred, once the newsprint had crumbled. I was never sure if it wasn't because . . . people had lost interest because non-violence was not on anyone's agenda, even if it *was* successful, or *because* it was successful." The remainder of Sheila's e-mail message, the first of many, named other persons she thought I might contact.

At the top of the list was Herbert Randall, Sheila's friend and former neighbor in New York City. I wrote to Mr. Randall, and one day, when I opened the mail, there

was a box of sixteen brown envelopes containing Herbert Randall's 1,759 negatives of Freedom Summer in Hattiesburg. I have not stopped looking at them ever since. It was immediately apparent, even from the small negatives viewed against the light of a slide table, that the photographs were works of art and not solely historical documentation.

Apart from a few images that I had seen in history books, most of Herbert Randall's Freedom Summer photographs had never been seen before. Although, as Randall later told me, he had allowed SNCC during the course of Freedom Summer to use any of his photographs that might be helpful in their civil rights activities, he was not a SNCC staff photographer and his Freedom Summer photographs were not part of SNCC's traveling exhibits. In fact, as far as I have been able to tell, they had never been exhibited.

Except for twelve images that had been included in Shirley Tucker's *Mississippi from Within* (New York: Arco, 1965), the negatives were not even printed until 1998. In that year Miguel Quiroga, staff photographer in USM's Photo Services Department, printed 831 of them for the Herbert Randall Freedom Summer Photographs collection in the USM Archives. Quiroga also printed the 102 photographs chosen for the "Faces of Freedom Summer" exhibition.

Even Herbert Randall had not seen his Freedom Summer photographs, apart from contact prints and the photocopies I sent him, until he attended the opening of the exhibit at USM on June 7, 1999. It was almost thirty-five years to the day since he had first focused his camera on the Mississippi Freedom Summer volunteers and clicked the shutter.

To capture Freedom Summer in Hattiesburg on film, Randall used three Pentax cameras with 35mm, 55mm, 105mm, and 200mm lenses. The people who have helped identify the individuals and sites shown in the photographs include Herbert Randall, Sheila Michaels, Victoria Gray Adams, J. C. Fairley, Daisy Harris Wade, Peggy Jean Connor, Glenda Funchess, Linda Williams, the Clark family of Palmer's Crossing, and the many local residents and former Freedom Summer volunteers who came to the USM Archives to see the entire collection.

Although the Freedom Summer photographs of Herbert Randall speak for themselves, a note on historical context may be useful for viewers too young to recall that memorable summer and for others whose memories need prompting.

Why Did They Come?

At issue was the fundamental American right to vote. In 1964, as USM historian Neil McMillen has shown, "Mississippi . . . lagged far behind even the most dilatory of its southern sisters. Elsewhere a quarter of a century of social ferment and rising black aspirations had appreciably broadened the region's attenuated electorate. But Mississippi . . . permitted fewer blacks to vote for Lyndon Baines Johnson in 1964 than had been eligible to vote for William McKinley in 1896. In a population of more than 422,000 eligible black citizens, only 28,500 (6.7 percent) were registered voters."[5]

In Mississippi the registrar of voters in each county could decide which citizens would be permitted to vote. In addition to paying a poll tax, each would-be voter was required to read a passage from the state constitution that

was selected by the registrar and to interpret it to the latter's satisfaction. "Whether field hand or college professor, domestic servant or physician, a black Mississippian could rarely meet the exacting standards of the county courthouse."[6]

Many of the white citizenry had reasons for wanting to deny blacks the vote. Segregationists believed that people of color were intellectually and morally inferior to Caucasians and that integration would result in intermarriage between the races. The segregationists had historically used physical violence and intimidation to keep black Mississippians in their place. Black citizens, had they been fully enfranchised, would have been able to participate in local government and might have demanded that government address the problems of poverty that afflicted black neighborhoods—unpaved streets, inadequate sewers and other city services, and, most important, inadequate education. A better education for black children was an important goal of the local activists of Freedom Summer. Equal opportunity was necessary if every person, black or white, was to have the chance to realize his or her potential, economically and otherwise. Under the administration of President Dwight Eisenhower, the U.S. Department of Justice had begun investigating allegations of bias on the part of county registrars in the South in their implementation of registration procedures. The first federal lawsuits challenging restrictions on voting rights in Mississippi were filed in 1961.

Student Nonviolent Coordinating Committee

Unwilling to wait for the slow grind of the wheels of federal justice, SNCC decided to take its own action in Mis-sissippi. The idea of Freedom Summer was conceived in 1963 by Bob Moses, the now legendary black SNCC field secretary from New York, and Allard Lowenstein, a white law professor at the University of North Carolina. Moses was doing voter registration work in Mississippi at the time. He and Lowenstein had support from SNCC staff member Fannie Lou Hamer, a black sharecropper's daughter from the Mississippi Delta, and Lawrence Guyot, a Tougaloo College graduate from Pass Christian on the Gulf Coast.

The Student Nonviolent Coordinating Committee had been organized in 1960 in North Carolina to coordinate the activities of black college students who had begun their own civil rights movement by sitting down on stools at segregated lunch counters and refusing to leave until they were served. These were the sit-ins of the early 1960s. Burned with cigarettes and drenched with ketchup by segregationists while they sat patiently, without retaliation, on their lunch counter stools, the SNCC activists would not be moved. The legendary Ella Baker, appreciating the idealism and energy of the young SNCC workers, supported them and persuaded Dr. Martin Luther King's Southern Christian Leadership Conference (SCLC) to provide partial funding for their activities.

The college-age men and women of SNCC (pronounced "Snick") were committed to nonviolent social change. The SNCC "Statement of Purpose" read, "We affirm the philosophical or religious ideal of nonviolence as the foundation of our purpose, the presupposition of our faith, and the manner of our action. Nonviolence as it grows from the Judaeo-Christian tradition seeks a social order of justice permeated by love. . . . By appealing to conscience and standing on the moral nature of

human existence, nonviolence nurtures the atmosphere in which reconciliation and justice become actual possibilities."[7]

The creative force behind Freedom Summer was Bob Moses, who held a degree in philosophy from Harvard University. SNCC philosophy was influenced by both the faith and the effective nonviolent strategy of Mahatma Gandhi, whose leadership of thousands of patient but persistent Indians had successfully forced the British to quit India, the jewel in the British Imperial crown. SNCC's approach was also influenced by the concept of the lay saint in the writings of the French Existentialist Albert Camus. Bob Moses, extremely intelligent and quietly charismatic, managed to affect everyone with whom he came in contact. Mississippi civil rights activist Anne Moody remembered, "I thought Bob Moses . . . was Jesus Christ in the flesh."[8]

In 1963 Moses proposed to the SNCC leadership that a mass voter registration drive be launched throughout Mississippi the next summer. He envisioned bringing into the state large numbers of America's best and brightest college students and other concerned citizens. These recruits would need to have funds of their own or to be sponsored by organizations like the National Council of Churches, because they would have to pay their own expenses and provide their own bail money. It was hoped that with national media attention the federal government would be forced to intervene to protect civil rights workers and to ensure equitable implementation of voting procedures. In McComb, Mississippi, Moses had learned that it did not seem to matter when local blacks or individual volunteers were jailed, beaten, or killed by people who opposed black voting rights.

Moses and the other outside agitators who came to Mississippi that summer of 1964 believed in the fundamental decency of Americans who would, when their eyes were opened to the truth of racial inequality, make it right.

Council of Federated Organizations

Other civil rights organizations were directing their attention toward Mississippi in the early 1960s. In addition to the Southern Christian Leadership Conference, there were the Congress of Racial Equality (CORE) and the Mississippi State Conference of local chapters of the National Association for the Advancement of Colored People (NAACP). With SNCC these groups formed the statewide Council of Federated Organizations (COFO), which oversaw the logistics of Mississippi Freedom Summer and distributed the funds for voter registration efforts that were provided by the Southern Regional Council. Dr. Aaron Henry represented the Mississippi NAACP as COFO president; Bob Moses represented SNCC as COFO project director and Freedom Summer program director; and Dave Dennis of CORE served as COFO assistant program director. In actuality, the COFO staff, headquartered in Jackson and operating at forty-four sites throughout the state, consisted almost entirely of CORE and, especially, SNCC workers. SNCC transferred its national headquarters from Atlanta, Georgia, to Greenwood in the Mississippi Delta for the duration of Freedom Summer. The young men and women of SNCC made up all of the COFO staff in Hattiesburg.

The fact that SNCC was so heavily involved in Mississippi Freedom Summer is significant, because SNCC in the early 1960s was famous for its loose, flexible organization; its refusal to glorify its own leaders; and its ability to

enhance the efforts of existing local leaders. These qualities made it a perfect match for Hattiesburg, which already had a strong local network of civil rights activists.

Mississippi Freedom Summer

COFO used the state's five congressional districts to organize its Freedom Summer activities and focused its efforts on cities and towns; the rural areas were considered too dangerous. The fifth district included the cities of Hattiesburg, with a population of some 35,000 residents located in the Pine Belt of south Mississippi; Laurel; and Gulfport, Biloxi, and Pascagoula/Moss Point on the Gulf Coast. Some of the other COFO sites in Mississippi were the state capital of Jackson, in the center of the state; cities like McComb, Meridian, Natchez, and Vicksburg; and small towns like Itta Bena and Elvis Presley's hometown of Tupelo.

COFO's "Outline of Mississippi Project Areas" described the Hattiesburg area of Forrest County (named after Confederate cavalry general Nathan Bedford Forrest, whose name was associated with the beginning of the Ku Klux Klan during the Reconstruction period following the Civil War):

Forrest County: Hattiesburg is the county seat. The circuit clerk is under court order to cease discriminating against Negro applicants. Almost continually since January 22nd, local Negroes have been picketing the county courthouse. There have been arrests on a variety of charges. Intensity of police harassment seems dependent on the amount of activity taking place. There is a strong core of local [black] leadership of both adults and students. The power structure seems to be keeping local white violence down. Workers should expect to operate in adjacent counties also. The [black] community seems enthusiastic about the program. We expect Hattiesburg to be one of the key centers of activity this summer.[9]

The African American portion of the population of the fifth district, an area of lumber companies and small farms with tourism and fishing on the Coast, was about 30 percent, in contrast with over 60 percent in the second district, which included the Mississippi River Delta with its cotton plantations.

Hattiesburg was the largest COFO site, in terms of the number of local participants, volunteers from outside the state, and Freedom School students. Sheila Michaels estimates the number of volunteers at "90-odd counting the medical people who came for a week or two at a time to run the health clinics, and the lawyers on the legal aid projects. We were far & away the largest project in the state. . . . We had about 3,000 participants from Hattiesburg, for the most part involved in the Freedom Schools, Community Centers, and the Freedom Democratic Party/Voter Registration drive."

Mississippi Freedom Summer was planned by COFO as a well-organized project with clear goals and a fourfold approach, as announced in COFO's "Prospectus for the Summer":

It has become evident to the civil rights groups involved in the struggle for freedom in Mississippi that political and social justice cannot be won without massive aid from the country as a whole, backed by the power and authority of the federal government. . . . Therefore, a program is being planned for this summer which will involve the massive participation of Americans dedicated to the elimination of racial oppression. Scores of students, teachers, professors, ministers, technicians, artists, and legal

advisors are now being recruited from all over the country to work in Mississippi this summer. Within the state intensive preparations have been underway since mid-January to develop structured programs which will put to creative use the talents and energies of the hundreds of expected summer volunteers. These programs can be divided generally into four main areas: Freedom Schools, Community Centers, voter registration, and special projects.[10]

Freedom Schools, the idea of Charlie Cobb, a SNCC field secretary and Howard University graduate, were designed to supplement the inadequate black public schools in the racially segregated local school systems by offering remedial work in basic subjects as well as classes in subjects not generally available in black public schools in Mississippi, like typing, foreign languages, and black history. The Freedom Schools provided instruction in government that related directly to voter registration. They also offered the students experience in creative expression through poetry, art, and role-playing. It was thought that such activities would engender self-confidence in people who had historically been oppressed. The long-term goal of the Freedom Schools was to produce new young local leaders. The COFO planners, including Staughton Lynd, a history professor at Yale University who headed the Freedom School program in Mississippi, expected a total enrollment that summer of about 1,000 people, mostly high school juniors, to be taught by some 200 volunteer teachers in fifty Freedom Schools. To the organizers' surprise, on the first day of class in Hattiesburg alone, over 600 students, from small children to elderly adults, came to be enrolled.

The Community Centers of Freedom Summer were directed at the adult members of the black community.

They offered a centralized location for community organizing and classes in literacy, nutrition, health, and prenatal care. Their purpose was to facilitate organized community efforts that would persist long after the volunteers had gone home. The first Community Center in the Hattiesburg area was located in Palmer's Crossing, a historically black community on the outskirts of Hattiesburg. The Palmer's Crossing Community Center housed a large Freedom School library, which contained books and other materials donated by Americans from all over the country. The Community Center also displayed exhibits of poems and artworks by students at the Freedom School. Other Freedom School libraries were located in the Woods Guest House and at Mt. Zion Baptist Church in Hattiesburg.

COFO's third objective, and the ultimate goal of Freedom Summer, was voter registration. It became evident early in the year that the regular state Democratic Party (for all practical purposes the only national political party in Mississippi) would continue to deny participation to even those few blacks who managed to pass the test of the county registrars of voters. Accordingly, Mississippi blacks in April organized an alternative party, the Mississippi Freedom Democratic Party (MFDP). Its delegates, elected by over 80,000 black Mississippians in several Freedom Votes, challenged the all-white Mississippi delegation to the regular Democratic Party's 1964 presidential nominating convention in Atlantic City, New Jersey. Among the founders and officers of the MFDP and also serving as MFDP delegates to the Atlantic City convention were Hattiesburg residents J. C. Fairley, Peggy Jean Connor, and Victoria Jackson Gray. Gray also ran on the MFDP ticket for John Stennis's seat in the U.S. Senate and participated in the MFDP challenge of the Mississippi

congressional delegation in the U.S. House of Representatives.

The fourth area of concentration for Freedom Summer included research projects designed to document areas of need and racial injustice in the state. In addition, there were the teams of lawyers who came to Mississippi to represent civil rights workers when they were arrested or assaulted. Two groups of lawyers were the Guild and the LCDC. The Guild was the Lawyers Guild Committee for Legal Aid to the South. The Lawyers Constitutional Defense Committee (LCDC) was composed of the Lawyers Committee for Civil Rights Under Law, the NAACP's Legal Defense and Educational Fund, and attorneys sponsored by the American Jewish Committee, the American Jewish Congress, the American Civil Liberties Union, and CORE. The LCDC rotated forty attorneys into the state. In addition, the Law Students Civil Rights Research Council provided fifteen students as the attorneys' law clerks. Doctors and nurses were provided by the Medical Committee for Human Rights (MCHR).

An important part of COFO's fourth front was the Free Southern Theater, a traveling repertory company that was founded by SNCC workers Gilbert Moses and John O'Neal. One of the members of the FST was Gilbert Moses' wife, actress Denise Nicholas, who later became familiar to television audiences from her recurring roles in the series *Room 222* and *In the Heat of the Night*. During three days in August of Freedom Summer, the FST staged performances in Hattiesburg of Martin Duberman's *In White America,* a play composed of passages from historical American documents dating back to the days of slavery. Thirty-five years later, on September 17, 1999, USM theater professor Francis X. Kuhn staged on the USM campus his dramatic reading *Voices of Freedom Summer,* which was a similar compilation but of the words spoken and written by the participants in Freedom Summer.

Folksingers were everywhere in 1964. There was the Mississippi Caravan of Music, which included Judy Collins and the legendary Pete Seeger. Seeger performed in the Palmer's Crossing Community Center and visited the Freedom Schools in Hattiesburg on August 4. There was the Roving Band led by Julius Lester, now renowned as the author of children's books. One of Lester's troupe, "Folksy" Joe Harrison, stayed behind in Hattiesburg when the troupe moved on and was a great favorite with the workers and the children. Another group in town for performances was Chuck Neblett's Freedom Singers. The 1960s moved to the songs of socially conscious folksingers.

SNCC Orientation Sessions

Before COFO allowed the volunteers to come to Mississippi, they were screened to weed out those who might endanger themselves or others. Those who passed the test were sent to SNCC orientation sessions, which provided instruction in the goals of Freedom Summer and in the techniques of nonviolent self-defense. The first SNCC orientation session was held in mid-June at Western College for Women in Oxford, Ohio. Herbert Randall began his photographic essay on Freedom Summer at the second SNCC session, held there June 22–27. A total of 900 volunteers, 135 of them African Americans, attended the two Oxford sessions.

Approximately 1,000 volunteers came to Mississippi for Freedom Summer. The first, core group of 650 came from thirty-seven states and England, Australia, and New Zealand. Most of its members were white and relatively affluent. They taught in the Freedom Schools, worked in

the Community Centers, did voter registration canvassing, bailed the civil rights workers out of jail and represented them in local courts, advised on health matters, and generally interacted with the black community but on an equal footing, not as overlords. Their COFO supervisors were mostly SNCC, mostly black, and mostly younger than they were.

Local Heroes

When the SNCC staff arrived in Hattiesburg for Freedom Summer, they found an existing well-organized network of local black activists waiting to house, feed, and protect them and to work with them in meeting COFO's objectives.

In reality, in Hattiesburg Freedom Summer had begun back on January 22, when national civil rights activists had first joined with local blacks to demonstrate publicly for voting rights. That was the first Freedom Day, and it served as a model for others throughout the South. Bob Moses had organized Hattiesburg's Freedom Day with the help of SNCC workers John O'Neal and Lawrence Guyot and CORE's Dave Dennis. Throughout that cold rainy day, preserved in the photographs of SNCC staff photographer Danny Lyon,[11] hundreds of local African Americans lined up patiently in front of the Forrest County Courthouse to take registrar Theron Lynd's voter registration test. They were supported by a picket line of national civil rights leaders like Ella Baker and John Lewis of SNCC, James Farmer of CORE, Annelle Ponder of SCLC, and fifty pastors flown in by the National Council of Churches' Committee on Race Relations.

Moses was arrested (and in turn performed a citizen's arrest on the arresting officer John Quincy Adams), but the Forrest County police under Sheriff W. G. "Bud" Gray declined to arrest the picketers who did not disperse on order—"the first state-protected civil rights demonstration in the history of Mississippi."[12] Newly inaugurated governor Paul B. Johnson, Jr., who had succeeded segregationist Ross Barnett, was a native of Hattiesburg and had already observed in his speeches that continued racial oppression was bad for business in the state. But registrar Lynd, although under federal court order to cease inequitable implementation of voting procedures, allowed very few of the black applicants to register and persisted in applying his standard for months to come.

What began on January 22 as a single day of public demonstration turned into the "perpetual picket line" that continued throughout the spring of 1964 as the National Council of Churches flew in relays of ministers from all over the country. The men of the cloth called themselves the Hattiesburg Ministers Union, and they served under the leadership of Rev. Robert Beech, a Presbyterian minister from Illinois. Their headquarters were in the Negro Masonic Lodge on the corner of Sixth and Mobile Streets in the heart of Hattiesburg's black community. Beech's office was on the second floor. Part of the first floor was partitioned into sleeping areas with cots and pallets. Shower facilities were provided by Forrest County NAACP president J. C. Fairley, whose radio and TV repair service was located in the front of the same building. Beech remained in Hattiesburg throughout Freedom Summer and beyond, serving as spiritual adviser to the volunteers.

There had been home-grown civil rights activity in Hattiesburg since the 1950s, when black residents started trying to enroll at the segregated Mississippi Southern College (now the University of Southern Mississippi), a

public institution. One of these would-be students was Clyde Kennard, a black veteran who wanted to complete his college education while remaining at home in the Hattiesburg area. Kennard was denied admission repeatedly by president William D. McCain and was arrested on trumped-up charges of having stolen chicken feed. He was eventually convicted and sentenced to seven years in the state penitentiary. He died of leukemia while carrying out his sentence.

In 1964, at the center of the black community in the Hattiesburg area stood Vernon Dahmer, a prosperous businessman respected by blacks and whites alike, who inspired local activists like Clyde Kennard and Victoria Jackson Gray. Dahmer had housed, fed, and supported Hollis Watkins and Curtis Hayes from Pike County in southwest Mississippi, the first SNCC workers to arrive in Hattiesburg back in 1962. Vernon Dahmer would lose his life in 1966 defending his family when their home was firebombed on orders from Sam Bowers, the Ku Klux Klan wizard from neighboring Jones County. The Hattiesburg Chamber of Commerce, under the leadership of Ralph Noonkester, the president of William Carey College, raised part of the money to rebuild the Dahmers' house. Bowers was finally convicted of the murder in 1998 in Hattiesburg. The Freedom Summer volunteers recalled Vernon Dahmer fondly: "That dear man kept us all alive on crowder peas."[13]

Victoria Jackson Gray was a young wife and mother, owner of a beauty supply business, who on her own initiative started offering adult literacy classes, using as her textbooks the Mississippi constitution and the Forrest County voter registration form. When Watkins and Hayes transferred to the Delta in the fall of 1962, Gray assumed their responsibilities as SNCC field secretary in Hatties-

burg. Her husband, Anthony Gray, also a civil rights activist, was fired from his job at the city waterworks the day after Freedom Day. Acid was thrown on the family car. The Jackson family was one of many black families in Hattiesburg and Palmer's Crossing that housed, fed, and protected the volunteers during Freedom Summer.

J. C. Fairley was co-owner with Mrs. Gray's brother Glodies Jackson of a radio-tv repair business located in the Masonic Lodge where the Hattiesburg Ministers Union was headquartered. Fairley was president of the Forrest County NAACP from 1962 to 1966, and he has played a major role in civil rights work in Hattiesburg since then. Daisy Harris worked with Fairley as Forrest County NAACP secretary. Harris had housed four ministers in her home on Freedom Day and took in two volunteers during Freedom Summer. Her youngest son, Anthony, was arrested at the age of eleven for under-age picketing of the courthouse. Fairley and Harris went on to lead a successful bus and business boycott in 1966–1967 that resulted in more equitable hiring practices in Hattiesburg businesses.

Near Fairley's shop in the 500 block of Mobile Street was the beauty salon of Peggy Jean Connor, one of the founders of the Mississippi Freedom Democratic Party. Connor, who had taught SCLC citizenship classes, served as MFDP executive secretary and was one of the leaders of the MFDP challenge to the Democratic Party's presidential nominating convention in August 1964. Her name heads the list of litigants in *Peggy Jean Connor v. Paul B. Johnson, Jr.*, which sought reapportionment of the Mississippi state legislature. During Freedom Summer she was the secretary-treasurer of the COFO-Hattiesburg Project.

When a reunion of the Freedom Summer volunteers with their local co-workers was held throughout Missis-

sippi in 1994, an honor roll of Freedom Fighters was drawn up. It included a number of Hattiesburg residents: Helen Anderson, Rev. J. W. Brown, Rev. John Cameron, Ruth Campbell, Peggy Jean Connor, Vernon Dahmer, Curtis E. Ducksworth, J. C. Fairley, Linda Galloway, John Gould, Victoria Gray Adams, Daisy Harris Wade, John Henry, Bennie Hines, Catherine Jackson, Glodies Jackson, Levater Jackson, the Killingsworth family, Charlie Knight, Mama Little, Georgia Martin, Rev. L. P. Ponder, Virgil Robinson, Clyde Shinault, Douglas Smith, Minnie Sullivan, Johnnie M. Walker, Ceola Wallace, and J. B. and L. E. Woods.

Critical to the success of Freedom Summer in Hattiesburg was the support provided by the pastors and congregations of the black churches both in Hattiesburg proper and in the neighboring community of Palmer's Crossing, now part of municipal Hattiesburg. They were, in Hattiesburg, Bentley Chapel United Methodist Church (the pastor in 1964 was Rev. L. P. Ponder), Morning Star Baptist Church (Rev. Cloudy Lumzy), Mt. Zion Baptist Church (Rev. F. L. Barnes), St. James Christian Methodist Episcopal Church (Rev. W. M. Hudson), St. Paul United Methodist Church (Rev. E. E. Grinnett), True Light Baptist Church (Rev. W. D. Ridgeway), and Zion Chapel African Methodist Episcopal Church (Rev. G. W. Robinson); and in Palmer's Crossing, the Priest Creek Missionary Baptist Church (Rev. I. C. Allen) and St. John United Methodist Church (Rev. L. P. Ponder).

Freedom School classes met in these churches by day, and the adult classes met there in the evenings. The churches' fellowship halls were the site of COFO staff meetings and political workshops. Mass meetings were held in the church sanctuaries so that people could listen to inspirational speakers and sing the songs of the civil rights movement, like "We Shall Overcome," always sung as the audience members stood with their arms crossed, clasping one another's hands. The members of the congregations housed and fed the volunteers. The men stood guard with guns all night while the volunteers slept in their homes. The women cooked meals for the volunteers and helped in the Freedom Schools and at the Community Center. The church members participated in voter registration canvassing and sent their children to the Freedom Schools. And all of these people understood that they were running the risk of physical violence and losing their jobs, thus denying the age-old shibboleths of the segregationist society, which maintained that "the Colored" wouldn't vote even if they had the opportunity, that they weren't interested in—or were incapable of—being educated for more than service as field hands and maids, and that they were content with their lot in life.

Today, the congregations of the black churches who made Freedom Summer successful in Hattiesburg are justifiably proud of the role they played thirty-five years ago. Mt. Zion Baptist Church, under the inspiration of Hattiesburg attorney Glenda Funchess, who was herself a student in the Freedom School held at Mt. Zion, each year on the Sunday before the birthday of Martin Luther King, Jr., honors a local hero of the movement. On Sunday, November 14, 1999, Mt. Zion Baptist Church unveiled the first Mississippi state historical marker honoring a civil rights site in Hattiesburg.

The local activists were very courageous. And they were smart and effective. Sheila Michaels commented on the network created by black residents and earlier SNCC and CORE workers that awaited the Freedom Summer workers when they arrived: "Hollis & Curtis, Dave Dennis, Guyot & . . . John O'Neal had built a rock-

solid base for us. No matter what kind of genius [COFO Project Director] Sandy Leigh had for administration and organizing, 3,000 people don't rise up and organize themselves in six months. We had to house those 90-some [volunteers], too, don't forget. And you don't let a cardiac specialist or an eye doctor from Detroit hang around all day with nothing to do. . . . Sandy had a superb base built up even before he got here. The townspeople were incredible."

Local Whites

The attitude of most white people in Hattiesburg during Freedom Summer was, with some notable exceptions, peaceful and passive, which, for Mississippi in 1964, was saying a great deal. Boston University professor Howard Zinn, SNCC's faculty adviser, recalled that "Hattiesburg, a short drive from the Gulf in Southern Mississippi, had been looked on by SNCC workers with some hope, ever since Curtis Hayes and Hollis Watkins left school in the spring of 1962 to start a voter registration campaign there, at the request of their McComb cell-mate, Bob Moses. . . . 'Hattiesburg,' one of the reports to [SNCC headquarters in] Atlanta read, 'is fantastic material for a beautifully organized shift from the old to the new.'"[14]

There is anecdotal evidence that Freedom Summer activities were quietly supported by a few unnamed local whites who donated money and food. The *Hattiesburg American* refrained from racist demagoguery. But the sole publicly outspoken white proponent of voting rights for blacks was Rabbi Charles Mantinband of Temple B'nai Israel. He had made a reputation during the 1950s and early 1960s as one of the few white Mississippians who publicly supported full civil rights for black Missis-

sippians. Rabbi Mantinband left Hattiesburg in 1963. Nonetheless, when Freedom Summer volunteer Rabbi Arthur J. Lelyveld was beaten and hospitalized, local Jewish business owners took up a collection to pay his medical bills.

The story of the local whites who quietly, invisibly supported the civil rights movement in Hattiesburg or allowed it to succeed has yet to be written. They did not, however, include University of Southern Mississippi president William D. McCain. McCain's personal views led him to give speeches across the nation on behalf of the racist White Citizens Councils, and he discouraged USM faculty from engaging in political activism. As he said, "There has been a lot of trouble with college professors on the matters of integration and segregation. We don't have that trouble at Southern. Each year I tell our instructors they are employed to teach . . . and I will handle all other problems."[15] Sheila Michaels recalls late-night visits to the COFO office by white male USM students who came "to talk." They made her nervous.

The University of Southern Mississippi, under President McCain, peacefully integrated its student body the year following Freedom Summer.

Volunteers

The volunteers came to Hattiesburg for Freedom Summer from many parts of the United States and for many reasons. Some of them had influential family connections, and many of them continued to have careers of service to their fellow human beings after the summer had passed.

The seven Freedom Schools in Hattiesburg and Palmer's Crossing were under the supervision of Arthur and Carolyn Reese, an African American couple from

Detroit, Michigan. He was a principal in the Detroit public school system, and she, a teacher. While in Hattiesburg they stayed in the Woods Guest House next to COFO headquarters. There were typically seven or eight teachers in each Freedom School. Two very popular teachers in the Freedom School at Mt. Zion Baptist Church were Dick Kelly and Paula Pace. Pace's father was secretary of the army in the Truman administration, and during Freedom Summer she stayed in Daisy Harris's home. Kelly, a University of Chicago student in 1964, returned to Hattiesburg for the 1994 Freedom Summer reunion and was surprised to find himself regarded as a hero of the movement. He commented, "You changed us. Our lives were never the same after that summer, but better. When summer was over, we went home. You had to stay here and continue to fight. You are the real heroes of the movement and I congratulate you every one for the danger you endured for freedom."[16]

St. Paul United Methodist Church's Freedom School had one teacher, a black Charlestonian named Luther Seabrook. When asked why he had chosen to come to Mississippi that summer, Seabrook, now recently retired from his position as a senior official in the South Carolina Department of Education, replied, "To confront my fear." While he was in Hattiesburg he was a passenger in the car in a police harassment incident that volunteer Lorne Cress described in an affidavit to COFO lawyers. The Hattiesburg policeman Seabrook remembers as "the fat mean cop" put the muzzle of his gun against Seabrook's ear and threatened to pull the trigger. I asked Dr. Seabrook if he had been afraid at that moment, but he said no, that he was just curious to know if there would be a lot of noise when the gun went off.[17]

One of the Freedom School teachers at True Light Baptist Church was Peter Werner, a naturalized American whose family had fled Nazi Germany. In 1964 he was a graduate student in nuclear physics at the University of Michigan. His own affidavit told how he had been struck from behind as he and two other volunteers, Susan Patterson (white) and William D. Jones (black), were entering the Walgreen's store in downtown Hattiesburg. Werner, who had not defended himself, and the white man who assaulted him were both arrested.

Some of the teachers at the Freedom School held at Priest Creek Missionary Baptist Church in Palmer's Crossing were Sandra Adickes, who with her students would shut down the Hattiesburg Public Library; Joseph Ellin from Michigan; Robert Stone, son of the prominent American architect Edward Durrel Stone; and Maria Halett, whose husband Greg taught in Palmer's Crossing's other Freedom School at St. John United Methodist Church. Also teaching at St. John were Doug Tuchman; Stanley Zibulsky of New York, who stayed a second year in the Freedom Schools; and Jean Wheeler (Smith), a Howard University student who left Hattiesburg to head the project in Philadelphia, Mississippi, the site of the murders of Schwerner, Chaney, and Goodman. Also associated with the Freedom Schools in Hattiesburg were Otis Pease, a professor at Stanford University; Joseph Ellin's wife, Nancy; Doug Baer; Beth More; Susan Patterson; and Patricia Yorck. State Freedom School coordinator Staughton Lynd made several visits to Hattiesburg during Freedom Summer.

Carefully identified with the initials VR, for "voter registration" in a 1964 State Sovereignty Commission report were Yale University student Jacob Blum, Stuart Rawlings, Peter Stoner, Paul Terrell, and Johanna "Johnnie" Winchester. Stoner, a University of Chicago student who had

been in Hattiesburg doing voter registration canvassing in the spring, had been arrested and sent to the county work farm. He later transferred to Tougaloo College and, making his home in Mississippi, received a doctorate from USM.

Phyllis Cunningham served from headquarters in Hattiesburg as the COFO state coordinator of health clinics and remained in Mississippi through the following year. Lorne Cress, a black volunteer from Chicago, was in charge of the Community Center activities in Hattiesburg and Palmer's Crossing. Some of the COFO attorneys in Hattiesburg were Eugene Crane of Chicago and Eleanor Jackson Piel, wife of the publisher of the *Scientific American*. The passing folksingers were the illustrious Pete Seeger, Julius Lester and his guitar band, "Folksy" Joe Harrison, Chico Neblett's Freedom Singers, and Gil Turner, Carolyn Hester, and Alix Doblin.

Other volunteers in Hattiesburg were Ben Achtenberg, Nick Allis, Anthony "Arrow" Beaulieu, James Campbell from Charleston, Marion Davidson (who spent a second year in the nearby city of Laurel), William Doyle (a professor at Chabot College), Tom Edwards, Bob "Soda Pop" Ehrenreich, Dickie Flowers, Jinny Glass, Linda Hamilton, Dave Hawk, Margaret Hyatt, Denise Jackson and William D. Jones (both black volunteers), Gregory Kaslo, Dick Landerman (who remained through 1965), Morton Mulvain, Rev. James Nance, Bill Ninde, David Owen, Diane Runkle, Andy Rust, Barbara Schwartzbaum (who also stayed through 1965), Lawrence Spears (who also served in Laurel), Walter Walters, Chris Wilson, and Malcolm Zaretsky.

And then there were "Danny," "Emily," "Big Daddy," "Eric," "a cardiac specialist," "an eye doctor from Detroit," "the black guy from Connecticut," and "the woman whose identity is driving me nuts." And there were others who have not yet been identified.

Hattiesburg COFO Staff

Waiting for the volunteers coming to Hattiesburg for Freedom Summer were the full-time COFO staff, SNCC field secretaries Sandy Leigh and Sheila Michaels, in the COFO office at 507 Mobile Street, located across the street and down the block from the Negro Masonic Lodge. The phone number was 584-9993. The building at 507 Mobile Street was owned by Lenon E. Woods, a member of a prominent black family and a memorable figure to the COFO workers and volunteers. The building was vacant at the time, and Woods offered it to COFO for use as their headquarters. She resided next door at 509 in the adjoining Woods Guest House, a historic two-story brick building built in the 1890s and furnished in style as one of the first black hotels in the area. Part of the Guest House was used as a Freedom School library.

Howard Zinn described COFO headquarters on the day before Freedom Day:

In the rundown Negro section of Hattiesburg, on a cracked and crooked street filled with little cafés, was SNCC's Freedom House. . . . Inside was cluttered with typewriters, mimeograph machines, charts, photos, and notices, and was filled with people and an incessant noise. . . . Upstairs, Bob Moses greeted me and took me past the big open parlor area where a meeting was going on planning strategy for the next day. . . . [Moses had] a combination bedroom and SNCC office, with a huge mirrored closet, carved mahogany bedstead, four typewriters, a gas heater, a suitcase, a wash basin, a map of Hattiesburg, and a vase of flowers.[18]

Sheila Michaels describes the back room of the COFO office during Freedom Summer:

We had a dresser on the far wall & three beds in the room. We kept the closet full of clothes which had been sent down by Northern groups. They were free to anyone who wanted to go through the bags, of course, but also handy to sack out on away from the traffic through the room to the kitchen & the back waiting room.

I remember sleeping in that room with three or four guys from the project the night (or the night after) Schwerner, Goodman & Chaney disappeared. I didn't want to leave the office & didn't want it unoccupied, because we had a group coming from Oxford [Ohio] who were on the road the night after their disappearance. The guys didn't want me sleeping alone in the office. Besides, we had no car & it was dangerous to walk home that time of night. We kept waking each other up joking about the Klan coming in & finding us just as they suspected, all sleeping together.

The Hattiesburg [train] depot had fewer comings & goings. We had beds in the room behind the office & showers attached. Many volunteers stayed in houses without running water & they would manage to get by the office after a week of dipper baths after stomping the countryside canvassing.

The director of the Hattiesburg COFO project was SNCC field secretary Sanford Rose Leigh, a twenty-nine-year-old former officer in the U.S. Army who came from Bridgeport, Connecticut, and had attended the Army Language School at Yale University. Sandy Leigh spoke four languages and was a gifted pianist. As an experienced SNCC activist—he had served as Bayard Rustin's assistant in organizing the March on Washington—he was a formidable organizer with outstanding people skills. Sheila

Michaels describes how Leigh worked each day during Freedom Summer:

Sandy worked out of the office a lot. He tried to get around to most of the locations on the project every day or so. Certainly two or three times a week. He kept his hand on the pulse locally & spent a lot of time finding out how Hattiesburg people felt about working with volunteers & adjusted the volunteers & the programs accordingly. He also had a lot of meetings with local people who were not involved in the project. He tried not to go to many SNCC or COFO staff meetings [in Greenwood and Jackson], so he was not away from the project often or for long. He did not suffer fools gladly, but nonetheless suffer them he did.

Sandy Leigh's deputy project director was a local teenager named Doug Smith. He was seventeen years old. Smith served as the youth coordinator for the Freedom Schools in Hattiesburg although he had not yet graduated from high school himself. Sheila Michaels described Smith's half-brother Howard "Poochie" Mobley, aged about fourteen, as "basically an invaluable person with no title or fixed job. . . . How anyone in the whole world could resist his charm is a mystery. What a wonder he was!" Leigh, Smith, and Mobley were black; the other staff members were white.

The project manager was SNCC field secretary Sheila Michaels, a resident of New York City who came originally from St. Louis, Missouri. Michaels had attended the College of William and Mary in Virginia and had worked in the office of the Freedom Movement in Jackson, Mississippi, in 1962. Her account of her responsibilities in the COFO office gives a good idea of what Freedom Summer in Hattiesburg was like—the action, the worries, the

logistics of bringing dozens of people into town for varying periods of time, the ever-present fear of violence:

My job was explaining to people that Sandy had some reason for . . . whatever. Ditto for every other head of something. I kept the records or made sure Sandy's records didn't get strewn around, & made sure everyone checked in at night. I made sure people had housing (someone else did most of that coordinating) & that sort of thing. We had a lot of visitors & short-term participants in programs, particularly older doctors & lawyers who had volunteered for a couple of weeks during their vacations, or who had brought things to us, like the library. We also had programs which rotated through, like the Free Southern Theater or the folk singers.

I eased the tensions between the various groups such as the community center people & the Freedom School people, the medical group & the &c. I cannot say I had the slightest idea of who people were & what they were doing & if they were stepping into someone else's magic circle: but I was supposed to see that they could do whatever the hell it was they were supposed to do or thought they were supposed to do.

Volunteers on the COFO office staff included Terri Shaw, who handled communications, and Joyce Brown. Sheila's account makes it clear that human beings, not angels, made Freedom Summer work:

I would try, on arrival, to find out who had been insulted or alienated permanently & who was embroiled in what Big Mistake. Occasionally I would sneak out to do voter registration canvassing with newcomers or anything else I could think of. . . . People would bring in their reports & we also took depositions, made up flyers, leaflets & stuff. I really cannot begin to think of all the things going on in the office most of the time.

Sandy would sometimes clear it out if it got too boisterous, but that was just to dim the decibel level. . . .

We often took dinner across the street [in the Roof Garden Café]. In the evening we'd have meetings or grind out more reports or publicity about the day. There was always someone in jail or just getting out & some group arriving that [COFO headquarters in] Jackson had neglected to tell us about. Sometimes I'd go out to meetings in the churches or with the volunteers, but for the most part, lacking transportation, I stayed in the office until about 9 or 11 o'clock. . . . If I left the office by 9, it was usually pretty safe to walk home alone, as people were still out on their porches. I tried to have all the volunteers contacted by 9, if they didn't call me. Some, of course, lacked telephones & would have to go to the neighbors to call in; or I'd have to call the neighbors & have them go over & look in. That was Sandy's "nonnegotiable" policy. If I was finished by 9, I would have a little time with Mrs. [Ceola] Wallace, my host [at 1000 East 7th Street]. Otherwise we'd talk in the morning.

Life in the COFO office that summer had its light side:

Around noon some of the ladies who had taken it upon themselves to feed the summer volunteers would come by with a little something extra from the covered dishes they'd brought somewhere else. We encouraged them to think of it as a highly competitive undertaking, on which depended their reputations as cooks. We encouraged them to think that the office staff were actually the final judges in this contest. . . . Sometimes the local guys would take me out & show me the local road houses, but I couldn't stay beyond dusk, as it really wasn't safe to be there after dark. I got to know the Hi-Hat Club [in Palmer's Crossing] pretty well & it was divine. It was also so crowded that it was safe enough. William & Mary was in a "dry" area, so I developed a taste for rotgut in college & I must say the bootleggers in Hattiesburg were miles beyond the Virginians.

Sheila's summary of a day in the COFO office is succinct: "We initiated. They reacted. We coped with that. Things happened, we reacted. There was always a truck sitting across the street with white men with a shotgun in the cab." SNCC field secretaries received a salary, when it was paid, of $9.64 a week.

COFO's plans for Freedom Summer and the arrival of the outside agitators did not go unnoticed. The Mississippi State Sovereignty Commission, a state spy agency that monitored the activities of civil rights workers and local activists alike, received reports from agents stationed throughout the state. There were two agents assigned to Hattiesburg. One of their typical reports notes that "this week many middle age and older people came into the city by carloads. They are for the most part teachers from various parts of the country. . . . Those who do not teach classes are still canvassing all over the country for negroes who will attend the 'freedom schools.' This week the project has had over 200 more negroes register for the schools, and the classes are beginning to be well attended."[19]

Freedom Summer in Hattiesburg

Vernon Dahmer kicked off Freedom Summer in Hattiesburg by hosting an Independence Day picnic on his property at the Kelly Settlement. Herbert Randall's photographs show Dahmer, COFO staff, local workers, and hundreds of volunteers eating catfish fried in huge kettles, singing songs, conversing, and riding on one of the Dahmer tractors driven by Doug Smith. Some of the volunteers who attended Dahmer's picnic stayed to work in Hattiesburg, while others departed for COFO sites in Laurel, McComb, and the Gulf Coast. To this day they recall Dahmer's picnic with joy. Sheila Michaels called it "something no one has ever forgotten. It was spectacularly wonderful."

A few days later came a sober reminder of the dangers of agitating for change in the state that Ole Miss history professor James Silver had characterized as a "closed society."[20] Rabbi Arthur J. Lelyveld, a prominent American religious leader who was in Hattiesburg with the Ministers Union, was walking with David Owen and Lawrence Spears, two young white male volunteers, near the railroad tracks. They were part of a group that included several young black women. Suddenly two white men got out of a pickup truck and assaulted Lelyved, Owen, and Spears with a tire iron. The rabbi had to be hospitalized.

The Rabbi was hit on the first blow, I on the second. I fell to the ground, dazed but conscious, pulled my knees to my stomach, my hands covering my back, as we had been taught at Oxford. The Rabbi stayed standing and took a number of blows. Larry was kicked.[21]

[The assailant] followed and kicked me with his work boots and struck me with his fists. He was swearing at me, calling me such things as "nigger lover," "white nigger," and "Commie," "Jew" and different combinations of these. . . . I can now understand much better the feelings of those who have worked long in Mississippi. And I can see why they have ulcers. You just can never know when it's going to come.[22]

Herbert Randall's photograph of a bloodied Rabbi Lelyveld was carried around the world by the wire services. The Rabbi's son Joseph, then a reporter on the *New York Times* and now the *Times*'s executive editor, recalls seeing Randall's photograph the next day on the front page of the *New York Journal American* with a banner headline reading "The Beaten Rabbi / Racists Did This."

The State Sovereignty Commission agents photographed the bullet-riddled Saab in which Herbert Randall rode into Mississippi: "Enclosed in this report are pictures of two autos that were fired on in Hattiesburg, Mississippi, at approximately 10:10 A.M., Monday, June 29, 1964. A white man with a rifle sitting on the back bed of a pickup truck allegedly fired the two shots. Witnesses claim that two other white men were riding in the cab of the truck."[23]

The SNCC records list twenty "incidents" that took place in Hattiesburg:

June 26: Hate literature from whites: "Beware, good Negro citizens. When we come to get the agitators, stay away."

June 29: Two cars owned by volunteers shot by four whites in pickup truck at 1:00 A.M. No injuries, $100 damage to each car. Three witnesses. (Owners were sleeping two blocks away.) [One of these cars was the Saab in which Randall rode to Hattiesburg.]

Civil rights worker charged with reckless driving, failure to give proper signal. Held overnight, paid fine.

Phone rings. Volunteer hears tape recording of last 20 seconds of his previous conversation. Someone goofed!

June 30: Whites in pickup truck with guns visible drive past [COFO] office several times. FBI checks June 29 car shooting.

July 2: Two voter registration canvassers followed and questioned by men describing themselves as state officials.

School superintendent threatens all janitors who participate in civil rights activity. Ditto at Holiday Inn.

Local police stop Negro girl, five white boys en route home. Policeman curses, threatens arrest, slaps one boy.

July 6: Owner's wife pulls pistol as 15–25 youngsters try to integrate drive-in. Youngsters run, are arrested and put in drunk tank by police. Three are roughed up.

July 8: Rev. Robert Beech of National Council of Churches [in charge of the Hattiesburg Ministers Union] arrested on false pretense charge after allegedly overdrawing his bank account $70. Bail set at $2,000.

Bottle thrown at picnic by passing car. No plates.

July 10: Rabbi [Arthur J. Lelyveld], two volunteers [David Owen and Lawrence Spears], two local teenagers [one of whom was Janet Crosby] attacked by two men as they walked in uninhabited area. Assailants escape after attacking three men. On emerging from [Methodist] hospital, rabbi says Jews in Mississippi should "stand up for decency and freedom with all risks involved" or leave the state.

July 14: State Sovereignty Commission visits [COFO] office.

July 16: Two voter canvassers stopped by police.

Police question those who complain about inadequate protection for those going to Freedom School; may charge them with threatening mayor.

July 18: Kilmer Estus Keyes, white, of Collins, Mississippi, turned self in to local police in connection with beating of Rabbi and two workers last week. Charged with assault; out on $2,500 property bond.

July 20: White volunteer [Peter Werner] beaten downtown as left bank [Walgreen store] with two other freedom school teachers [Susan Patterson and William D. Jones]. Assailant hit from behind. No words exchanged. Volunteers and attacker charged with assault.

July 25: Home of two local FDP [Mississippi Freedom Democratic Party] leaders bombed between 1 and 4 A.M. Broken whiskey bottle found indicated "molotov cocktail" type of device. Used on home of Mr. and Mrs. [Richard and Earline] Boyd, FDP temporary chairman and secretary.

Aug. 8: Two men, Clifton Archie Keyes, 51, and his nephew Estus Keys, 31, were tried today for the July 10 beating of Rabbi Arthur Lelyveld, 51, of Cleveland, Ohio. Pair pleaded nolo contendre [sic], waived arraignment, and paid fines of $500 each.

They also received 90 day suspended sentences on condition of good behavior. The charge was changed by District Attorney James Finch from assault and battery with intent to maim to simple assault and battery. [Rabbi Lelyveld would die in 1996 from a brain tumor which originated in the part of his head which received the blows of the tire iron used by his assailants, according to his widow Mrs. Teela Lelyveld.][24]

Aug. 12: Mrs. Dorothea Jackson, local Negro woman, arrested yesterday when she would not give her seat to white woman on bus. Mrs. Jackson was pulled off bus by policeman. She asserted that knife was planted in her purse. Charges as yet unknown.

Aug. 14: Local Negro citizen Willie Mae Martin re-arrested last night in connection with charge of resisting arrest and interfering with police officer last March. Billy McDonald, another Hattiesburg Negro resident, and FDP chairman Lawrence Guyot arrested at same time, McDonald on same charge as Miss Martin and Guyot solely for interfering. . . . Miss Martin and McDonald assigned $200 bond and 30 days imprisonment, and Guyot $100 and 30 days. It is doubtful that Guyot will be released before the Democratic National Convention.

Freedom School teacher Sandra Adickes, UFT [United Federation of Teachers] volunteer, arrested today when she attempted to have six of her students check out books from public library deemed for whites only.[25]

This last incident had positive long-term consequences. When Sandra Adickes, a New York teacher in the Freedom School at Priest Creek Missionary Baptist Church in Palmer's Crossing, asked her students what they would like to do in order to put into action what they had learned that summer, they chose to go to the main branch of the racially segregated Hattiesburg Public Library and ask to borrow books. So Adickes and six of her students—Curtis Ducksworth, Gwen Merritt, Carolyn and Diane Moncure, La Verne Reed, and Jimmella Stokes—went to the library. Their request was denied. The librarian called the police, and the police chief himself came to close the library. Next, Adickes and her students entered the nearby Kress Store to eat lunch at the counter. The students were served, as required by federal law, but Adickes was denied service and, upon leaving the store, was arrested for vagrancy. Adickes sued Kress. The case was appealed to the U.S. Supreme Court. She settled out of court and contributed part of her case settlement to the Southern Conference Educational Fund, stipulating that part of the gift must go toward the college education of Jimmella Stokes, one of her Freedom School students. Adickes recently retired from her position as professor of English at Winona State University in Minnesota. She has immortalized her Hattiesburg hostess, Victoria Gray's aunt Addie Mae Jackson, in her autobiographical novel *Legends of Good Women,* published in 1992. Adickes and Jackson, like many of the volunteers and their Hattiesburg hosts, became friends during Freedom Summer and remained in contact over the years with letters, phone calls, and visits. On October 22–23, 1999, the University of Southern Mississippi hosted a reunion for Adickes and her Freedom School students. They spoke to Neil McMillen's African American history class and, appropriately, at the annual conference of the Mississippi Library Association.

Hattiesburg's Freedom Schools

There were seven Freedom Schools for children and adults in Hattiesburg, which state Freedom School coordinator Staughton Lynd called "the Mecca of the Freedom School world."[26] The estimated total number of students

attending the Hattiesburg Freedom Schools was 650–675. They met every day in these black churches: Bentley Chapel United Methodist Church, Morning Star Baptist Church, Mt. Zion Baptist Church, St. Paul United Methodist Church, and True Light Baptist Church in Hattiesburg, and Priest Creek Missionary Baptist Church and St. John United Methodist Church in Palmer's Crossing.

There were two three-week sessions of Freedom Schools in Palmer's Crossing. The first session began on July 6, the second, on July 29. The announcement in the Palmer's Crossing Freedom Schools' *Freedom News* noted that "classes will be held during the mornings from 8 to 11 for the younger students, and from 7:30 to 9:30 every evening, Monday through Friday, for adults and those unable to attend the morning sessions. People who have completed one three-week session *will* be permitted to participate in the second session. New students are especially urged to come at this time, too."[27]

Teacher Sandra Adickes describes her Freedom School at Priest Creek Missionary Baptist Church:

Between forty and fifty young people, mostly high school students, came in the mornings for sessions that usually began with one big meeting in the church basement; then, when the temperature rose, as it always did, to more than 90 degrees, we moved the classes outside and sat under trees. In their schools, the students were made to use texts the white schools had discarded, issued to them with the names of the former users still on the labels. In freedom school, the students were delighted to be given clean, new paperbacks of *Go Tell It on the Mountain, Native Son, Black Boy,* and other books contributed by workers in the publishing industry. Even more than cast-off texts, however, the students resented being denied their heritage by teachers who were obliged to bow to the system to keep their job. By

contrast, attending freedom school was like "coming out of the darkness."[28]

In the afternoons some of the Freedom School teachers participated in voter registration canvassing. In the evenings they taught adult students. Adickes stated:

The approximately twenty adults who came to freedom school in the evening were more aware than the [younger] students were of the struggle necessary for mere survival and, indeed, often viewed the past with longing rather than scorn. . . . But the adults also revealed a sense of their limitations and missed opportunities. This became clear to me during a lesson on Negro poetry to which they enthusiastically responded. I began by playing the Folkways album *Anthology of Negro Poets,* with readings by Langston Hughes, Sterling Brown, Claude McKay, Countee Cullen, Gwendolyn Brooks, and Margaret Walker. . . . An older woman said that when she was in school, she had wanted to write poetry, but since that time, she had not felt the desire because writing poetry did not seem "important enough to set aside chores."[29]

The Freedom Summer organizers were clear about their goals for the Freedom Schools, as described in COFO's "Notes on Teaching in Mississippi":

You will be teaching young people who have lived in Mississippi all their lives. That means that they have been deprived of decent education, from the first grade through high school. . . . Most of all it means that they have been denied the right to question. The purpose of the Freedom Schools is to help them begin to question. . . . The key to your teaching will be honesty and creativity. We can prepare materials for you and suggest teaching methods. Beyond that, it is your classroom. . . . You will discover the way—because that is why you have come."[30]

The Freedom School students formed the nucleus of the Mississippi Student Union, founded in Hattiesburg and headquartered in the back room of the Negro Masonic Lodge. At the end of the summer, students from all over the state met at the Mississippi Student Union convention held August 8–9 in Meridian, Mississippi, where the "Declaration of Independence" written by students in the Freedom School at St. John United Methodist Church was accepted as policy by the entire convention and adopted as a plank in the platform of the Mississippi Freedom Democratic Party, with a copy sent to Governor Paul B. Johnson, Jr. The "Declaration of Independence" had been first published on July 25 in the students' mimeographed *Freedom News:*

In this course of human events, it has become necessary for the Negro people to break away from the customs which have made it very difficult for the Negro to get his God-given rights. We, as citizens of Mississippi, do hereby state that all people should have the right to petition, to assemble, and to use public places. We also have the right to life, liberty, and to seek happiness. . . .

The Negro does not have the right to petition the government for a redress of these grievances:

For equal opportunity.

For better schools and equipment.

For better recreation facilities.

For more public libraries.

For schools for the mentally ill.

For more and better senior colleges.

For better roads in Negro communities.

For training schools in the State of Mississippi.

For more Negro policemen.

For more guarantee of a fair circuit clerk.

For integration in colleges and schools. . . .

We, therefore, the Negroes of Mississippi assembled, appeal to the government of the state, that no man is free until all men are free. We do hereby declare independence from the unjust laws of Mississippi which conflict with the United States Constitution.[31]

The final COFO report on the Freedom Schools at summer's end concluded that "the transformation of Mississippi is possible because the transformation of people has begun. And if it can happen in Mississippi, it can happen all over the South."[32]

Did Freedom Summer Make a Difference?

Have things changed in Mississippi? the former volunteers ask me. And I ask the local people, Have things changed? Oh yes, they say.

The results of Mississippi Freedom Summer are in the numbers. As of August 1964, throughout the state, black citizens—17,000 of them—had walked into county courthouses and filled out voter registration forms. Of these, only 1,600 were allowed to register to vote. The Mississippi Freedom Democratic Party, however, had registered over 80,000 black Mississippians in a series of Freedom Votes. Between 3,000 and 3,500 students had attended the Freedom Schools taught by some 250 volunteer teachers at fifty locations throughout the state. There had also been 300 arrests of civil rights workers and volunteers, twenty-five bombings of homes and churches, and an unrecorded number of beatings and instances of intimidation and threats of violence. And Schwerner, Chaney, and Goodman had been killed.

At first, Freedom Summer seemed to have fallen short of its objectives, even to have been a failure. The MFDP delegates did not succeed in achieving admission to the

regular Democratic Party's delegation to the national presidential nominating convention held in August in Atlantic City. When offered the compromise of two at-large seats with the other MFDP delegates admitted as "guests" on the convention floor, Mississippi's Fannie Lou Hamer voiced the frustration of black Mississippians in her immortal reply, "We didn't come all this way for no two seats!"

As the fall of 1964 and the spring of 1965 wore on, SNCC found it difficult to staff the Freedom Schools and Community Centers. The organization foundered on physical exhaustion, low morale, and the rising idea of Black Power. Longtime white SNCC workers were no longer welcome in an organization where they had fought the good fight alongside their black co-workers, many of whom now wanted to make their freedom by themselves. The COFO coalition dispersed. At a SNCC retreat held in Waveland, Mississippi, in October and at a COFO meeting in Hattiesburg in December, the stresses and strains were evident: complaints about loss of momentum, Mississippi workers separating themselves from SNCC staff, diminishing financial support from traditional SNCC sources that disapproved of the black-only direction in which the leadership seemed to be headed, and so forth. And the war in Vietnam had begun to absorb Americans' attention.

But with the passage of years, as historians have evaluated Mississippi Freedom Summer, its success has been judged without qualification to be "enormous."[33] The effect of these few short months was a fundamental change in American society, with an impact that resonated around the world. Bob Moses' dreams and COFO's goals for Freedom Summer have been fulfilled to a large extent legally, culturally, and in the lives of individual Americans, black and white. The federal Voting Rights Act of 1965 came directly out of the voter registration efforts of Mississippi Freedom Summer and the Mississippi Freedom Democratic Party, with testimony given before the U.S. Congress by Fannie Lou Hamer and Victoria Gray. The federal Head Start program is the direct by-product of the Freedom Schools.

All of those volunteers, all of those ministers who came to Mississippi in 1964, went back home and told people what they had experienced. All of America watched Mississippi Freedom Summer unfold on national television and in the press. As Neil McMillen observed, "the project's success was to be found in media impact not registration figures. Quite literally, its triumph may be measured in column inches of newsprint and running feet of video tape."[34] And Bob Moses' belief in the fundamental decency of Americans was affirmed.

Even Hattiesburg, the largest and most successful Mississippi Freedom Summer site but oddly also the most neglected, has now begun to be recognized by historians. Clayborne Carson's 1981 *In Struggle* and John Dittmer's 1994 *Local People* describe the events and people of Freedom Day and Freedom Summer in Hattiesburg. Taylor Branch's 1998 *Pillar of Fire* devotes an entire chapter to Hattiesburg. Sheila Michaels remembers:

Well, we were given kind of short shrift in the Movement, too. Maybe because Sandy was much older than most Project Directors. . . . Or because he ran such a tight ship & his project thrived because we had good order & no civil wars & very little discrimination or hurt feelings & the Hattiesburgites were behind us 110% or kept it to themselves. Some people in SNCC headquarters resented this & they did not easily give him credit or publicity. Anyway, we kept things safe (& so did the towns-

people, black & white, I do believe) so we could actually register people & teach schools. Hattiesburg was often looked down upon as being "too tame" by those who were seeking a summer of danger. (I don't know, 30+ years I still don't sit with my back to the door in a restaurant: like a Mafia Don.) So, far from being the most important, because we were the biggest project in the state, we were "Oh, Hattiesburg . . . " even though they had to send us all their visiting dignitaries to show what "they" were doing.

And was Hattiesburg changed by Freedom Summer? The schools are now integrated, and job opportunities have improved ("Now, if you have the stuff, you get the job," a local African American told me). There are two African Americans on the city council, and one African American is a county supervisor in Forrest County. A prominent building on the University of Southern Mississippi campus is named in honor of Clyde Kennard and alumnus Dr. Walter Washington, the first African American to earn a doctoral degree from a Mississippi university, five years after Freedom Summer. Daisy Harris sent her two sons to USM. Dr. Anthony Harris, who had been arrested for under-age picketing of the courthouse, is now executive assistant to President Horace W. Fleming. J. C. Fairley, summing up a lifetime of civil rights leadership, said, "I'm grateful that the Lord let me live through it all to see this day."[35] However, Victoria Gray Adams reminds us that American society today has problems as difficult to solve as those it faced thirty-five years ago: "Drugs, gangs, violence and jobs. . . . I think another movement is out there. It needs to coalesce."[36]

You can see the biggest change—as it was happening—in the faces of the black children and teenagers who attended the Freedom Schools in Hattiesburg during Free-

dom Summer. You can see them awakening. And their faces will always be there to remind us, thanks to Herbert Randall.

Epilogue

They came to Hattiesburg, Mississippi, from everywhere on the first weekend in June 1999 to celebrate the thirty-fifth anniversary of Freedom Summer.

Some of them, like Herbert Randall, had not returned to Mississippi since he took his photographs in 1964. At the time, he had vowed that if he could get out of Mississippi without being maimed or killed, he would never go back. But with his family he attended the opening on June 7 of his one-man show "Faces of Freedom Summer: The Photographs of Herbert Randall." He and his wife, Rosalind, traveled from the Shinnecock Indian Reservation on Long Island, and their son, Dana, came with them from his home in Worcester, Massachusetts.

Victoria Gray Adams came from her home in Petersburg, Virginia. Sheila Michaels came from New York City. Sandy Leigh came from Northport, Alabama. Historian Dr. John Dittmer came from DePauw University in Greencastle, Indiana, to moderate a symposium of Freedom Summer leaders. Dittmer is the author of *Local People: The Struggle for Civil Rights in Mississippi,* which won Columbia University's Bancroft Prize for the best book published about American history in 1994. All were special guests of the university.

Other special guests were nine Freedom Summer leaders who came to participate in the symposium sponsored by the USM Libraries. In addition to Victoria Gray Adams, the generation of local Hattiesburg leaders who were adults in 1964 was represented by J. C. Fairley, Daisy Harris

Wade, and Peggy Jean Connor. Doug Smith spoke for the younger generation and the Freedom School students. Sheila Michaels and Curtis Hayes Muhammad, who came from New Orleans, represented SNCC. Dave Dennis, representing CORE, came from Jackson, where he heads the Southern Initiative of Bob Moses' The Algebra Project, and Rev. Bob Beech from Minnesota represented the Hattiesburg Ministers Project.

Others came from as far away as London, England, Costa Mesa, California, New York City, and Chicago. In 1964 they had been "outside agitators"; now they were "honored guests" of the University of Southern Mississippi. Some stayed in area motels. Others stayed with the African American families that had hosted them in 1964.

All of us joined together for four memorable days of activities, from Friday, June 4, through Monday, June 7. Three faculty members on the staff of the USM libraries—Kay Wall, director of public services; Toby Graham, head of special collections; and the author escorted the Randalls, Victoria Gray Adams, Sheila Michaels and her friend from CORE Mary Hamilton Wesley, Sandy Leigh and his caregiver Sarah Taylor, and John Dittmer.

Visitors began to arrive at area airports on Friday. Some came in early for the oral history interviews being conducted by Charles Bolton and the staff of USM's Oral History Department. Others had allowed plenty of time to revisit the people and the sites that they remembered from the summer of 1964. Lawrence Spears, whose home is in Bismarck, North Dakota, where he is executive director of the North Dakota Consensus Council, came from the Wharton School at the University of Pennsylvania, where he was studying on a Bush Fellowship. In Hattiesburg he roomed, as he had thirty-five years ago, with David Owen, who came from Urbana, Illinois. While he was in Hattiesburg, Spears spent some time walking along the railroad tracks to locate the spot where he and Owen had been assaulted with Rabbi Lelyveld during Freedom Summer. The assault and photographs of the site appear in Spears's FBI file, which he donated to the USM Archives.

Freedom School teacher Doug Tuchman came from New York City and stayed with his 1964 hosts W. B. McFarland and his wife. Also staying with the McFarlands was Umoja Kwanguvu. During Freedom Summer he had been William D. Jones, who was arrested for trying to integrate the Hattiesburg Public Library and who was with Peter Werner when Werner was assaulted outside the Walgreen's store in downtown Hattiesburg. On Kwanguvu's return trip, he visited the local police headquarters (now located in a different building from the one where he was jailed), where he says that he received a friendly welcome. He stayed with NAACP leader Raylawni Branch; attended the opening day trial of Charles Noble, accused of participating in the 1966 murder of civil rights leader Vernon Dahmer; and was interviewed by the local media. Kwanguvu donated to the USM Archives snapshots he took in 1964 of his Freedom School students.

Terri Shaw, now an editor at the *Washington Post,* came from Washington, D.C. She donated her accounts of Freedom Summer to the USM Archives. Freedom School teachers Joseph Ellin and his wife, Nancy, who had preserved a very comprehensive collection of Freedom Summer materials and a fine library of civil rights books, which they generously donated to USM, came from Kalamazoo, Michigan, where he is a professor of philosophy at Western Michigan University.

More visitors arrived on Saturday. That evening USM

president Horace W. Fleming and Mrs. Fleming hosted a dinner for the guests at the president's home. After dinner James Luvene, member of the board of the Institutions of Higher Learning (IHL), which oversees Mississippi's public colleges and universities, presented Victoria Gray Adams with a framed collage of pages from the brochure for the exhibit "Faces of Freedom Summer." The brochure had been designed by USM graphic design major Rolando Gumler.

Most of the visitors arrived in time for Sunday service at St. John United Methodist Church in Palmer's Crossing. The small sanctuary was packed to overflowing as the piano filled the room with joyous music throughout the service. Pastor Nathan Jordan was assisted by Victoria Gray Adams and Bob Beech. Reverend Beech came from Minnesota with his wife, Joan. Herbert Randall's sister, Barbara H. R. Joseph, and her daughter came from New York City; Doug Smith arrived from Clarksville, Tennessee; Lorne Cress Love, from Chicago; Joseph Schwartz, from London; Joe August, from Woodstock, New York; Lester Galt, from New Orleans; and Luther Seabrook, from Charleston, South Carolina. There were many others. Some of them had returned to Hattiesburg periodically over the years; some of them had not been back since 1964. Many had remained in touch with the local people whose dreams had brought them here thirty-five years ago. During the service at St. John, visitors would stand, identify themselves, and speak about their work during Freedom Summer in Hattiesburg, naming the people with whom they stayed and describing what the experience had meant to them.

Sandy Leigh received a standing ovation. Now suffering from permanent amnesia as a result of a beating he received in New York City in the 1970s, Leigh came from his home in Alabama with his caregiver, Sarah Taylor. At the conclusion of the service, everyone stood, joined hands, and spontaneously sang "We Shall Overcome." Lots of tears were shed. One of the local television stations covered parts of the service. The ladies of St. John had prepared lunch.

On Saturday and Sunday afternoons, while Herbert Randall met the representatives of the media in the museum, visitors and locals gathered in the Cleanth Brooks Reading Room of the McCain Library and Archives of the USM Libraries to renew old acquaintances and to share memories inspired by Herbert Randall's photographs. A high point of Sunday afternoon was the presentation by former SNCC research staffer Ira Grupper, to the USM Archives of the Ku Klux Klan poster reading "The Klan wants you!" which had been posted on the property of Vernon Dahmer shortly before his murder in 1966. Dahmer had given the sign to Grupper, who recalled that when he came to the USM Library to do research for SNCC in the 1960s, the only African Americans on campus were janitorial staff.

On Sunday afternoon all of us were photographed by the media as we gathered in the vacant lot at 507 Mobile Street that had been the site of COFO and MFDP headquarters during Freedom Summer. The building, a historic hotel for blacks built at the turn of the century, had been destroyed by fire in September 1998. Other buildings in the block had been weakened in a 1974 flood and then demolished, but the Negro Masonic Lodge at Sixth and Mobile Streets, which had been headquarters for the Hattiesburg Ministers Project, was still standing, looking as it appeared in Herbert Randall's photographs.

From Mobile Street we drove to Mt. Zion Baptist

Church for a reception arranged by former Freedom School student Glenda Funchess, now an attorney, and the ladies of Mt. Zion. Victoria Gray Adams's son Cecil Gray, chairman of the African American Studies Department at Gettysburg College, gave the address. In spring 2000, he and his mother taught a course about the civil rights movement in Mississippi in USM's History Department and, in February, gave the University Forum lecture honoring African American History Month.

Monday, June 7, was the culminating day of the four days of activities commemorating Freedom Summer in Hattiesburg. After lunch, which the USM Libraries provided for the special guests and symposium participants, guests and visitors gathered in the Mannoni Performing Arts Center for the Freedom Summer symposium. USM history professor Dr. Marjorie Wheeler, author of *One Woman, One Vote* and professor of the Freedom Summer seminar in USM's Honors College, served as emcee. Dr. John Dittmer was the moderator. After welcoming remarks from USM President Horace Fleming and Hattiesburg mayor Ed Morgan and the presentation by James Luvene of the IHL Board's certificate of recognition of Victoria Gray Adams's lifetime of service to the cause of human rights, the symposium participants shared with a large audience of students, faculty, visitors, and local people their memories of Freedom Summer in Hattiesburg.

J. C. Fairley explained the need for Freedom Summer in terms of the political climate and the denial of voting rights by local officials. He was followed by Daisy Harris Wade, who noted that she "never expected to be in this building without a mop in my hand." Sheila Michaels emphasized the work of local people such as Lenon Woods and Ceola Wallace. Peggy Jean Connor discussed lawsuits as an effective civil rights tool, and Bob Beech showed how Freedom Summer had led to the success of the civil rights movement. Dave Dennis explained how Bob Moses' current Algebra Project, like the Freedom Schools of the 1960s, seeks to use academic study to liberate disadvantaged students. Doug Smith spoke of the role of young people in Freedom Summer. Curtis Hayes Muhammad walked in late to the cheers of the audience and explained that he had been looking for the USM building that is named in honor of Clyde Kennard. Victoria Gray Adams suggested that today, as in the 1960s, all individuals can contribute to the betterment of the society in which they live. She then led the audience in singing the movement song "Get on Board." USM's Oral History Department taped the symposium.

At the conclusion of the symposium, actress Denise Nicholas, a member of the original Free Southern Theater repertory company, came onstage and was recognized. She was applauded by an audience that had cheered every high point of the symposium.

In her interview with WDAM-TV reporter Rochelle Dahmer, the granddaughter-in-law of Vernon Dahmer, Sheila Michaels acknowledged the historic role that SNCC and the volunteers had played in Mississippi Freedom Summer. She asked everyone to remember, however, that the outsiders had come to Mississippi because of "the people who were here—who knew what they wanted—and were able to find strength in each other. And that was what happened that summer."

Then everyone went next door to the USM Museum of Art for the formal opening of Herbert Randall's "Faces of Freedom Summer" exhibit, which had been curated by museum director Dr. Michael De Marsche and hung by students in USM's College of the Arts. There on the walls of the main gallery in 102 images were the faces of the

people who had made Freedom Summer happen. The media were present, including a writer for *People* magazine, which featured six of Herbert Randall's photographs in its July 5 issue. One of these photographs (voter registration canvassing of local resident Hattie Mae Pough by volunteer Dick Landerman) was a runner-up for the 2000 Alfred Eisenstaedt Award.

Some of the individuals whom Randall had photographed were present that day in the gallery—walking around, gazing at the photographs, sharing memories, giving interviews to the media, and enjoying the reception provided by USM's College of the Arts. Others were no longer alive or, like Sandy Leigh, were unable to remember that summer. The occasion, and the exhibit itself, will pass from memory. The photographs reproduced in this volume will ensure, however, that the faces of Freedom Summer are not forgotten.

Faces of Freedom Summer

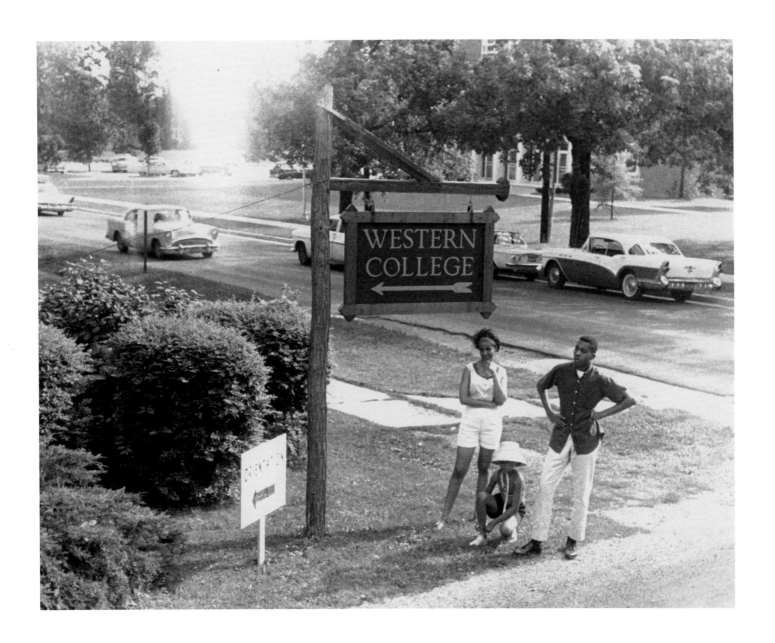

Western College for Women, Oxford, Ohio, the site of Freedom
Summer orientation

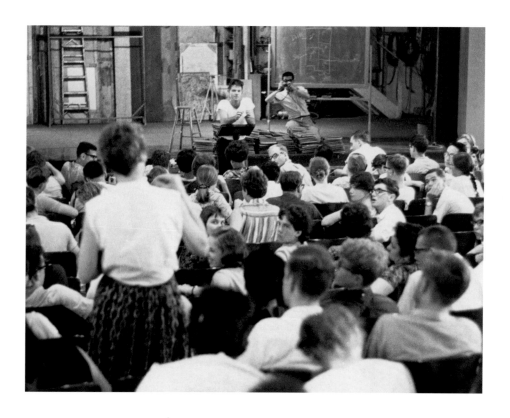

Staughton Lynd conducting a workshop for volunteer Freedom
School teachers

Opposite: Bob Zellner (Alabama) and Fannie Lou Hamer
(Ruleville, Mississippi)

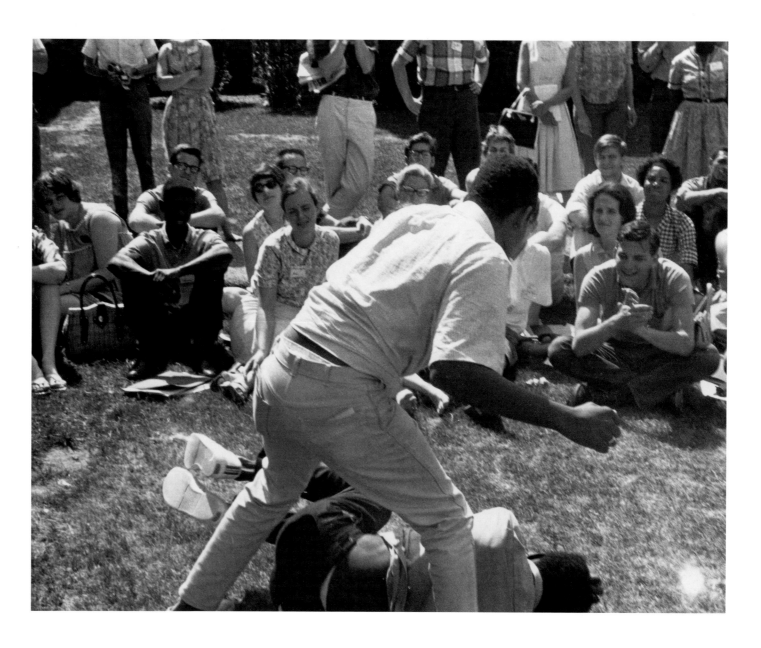

SNCC field secretary Cordell Reagon (Tennessee) giving
instruction in nonviolent self-defense

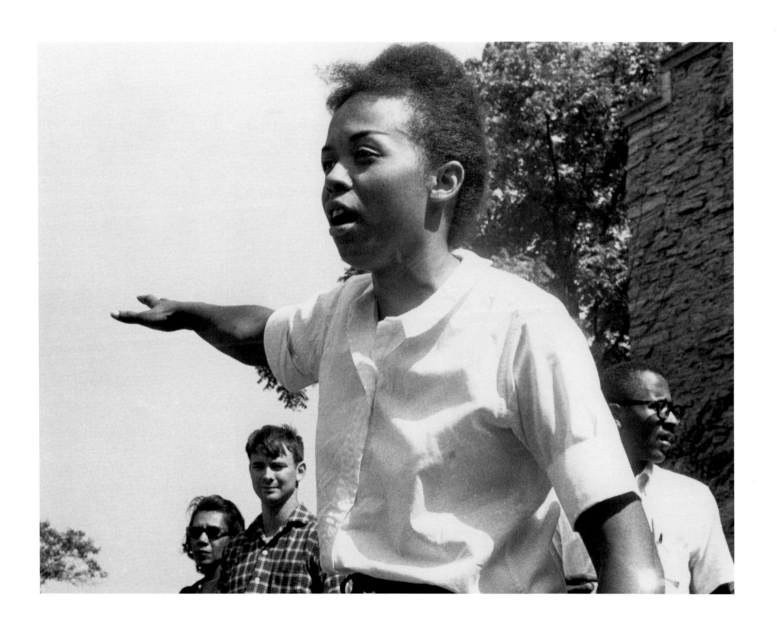

SNCC field secretary Dorie Ladner (Palmer's Crossing, Mississippi)

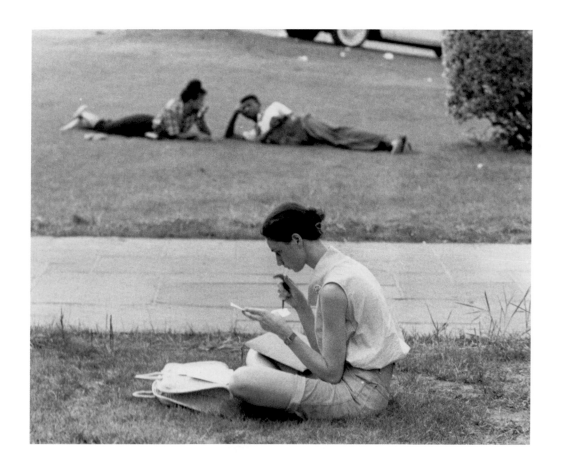

Above and Opposite: Freedom Summer volunteers

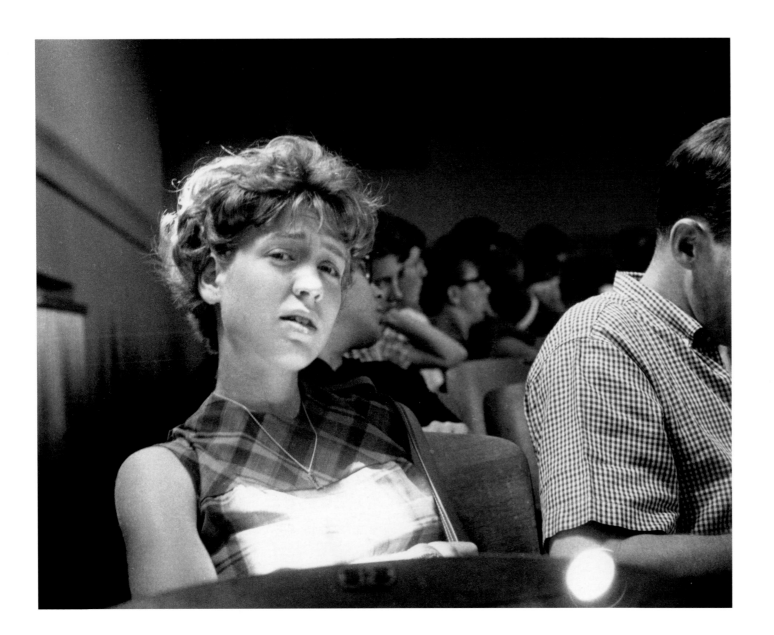

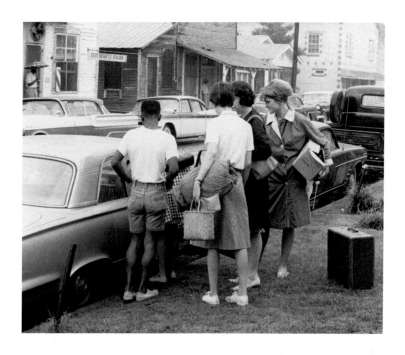

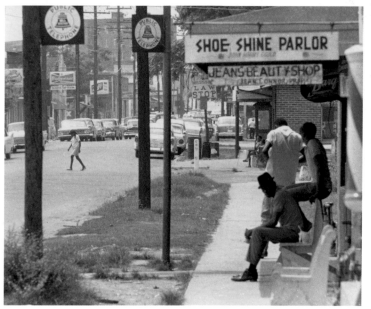

Above: Howard "Poochie" Mobley helping volunteers arriving at COFO headquarters at 507 Mobile Street

Left: The 500 block of Mobile Street across the street from COFO headquarters

Opposite: The 500 block of Mobile Street across the street from COFO headquarters. Shown: the business of local activist Peggy Jean Connor.

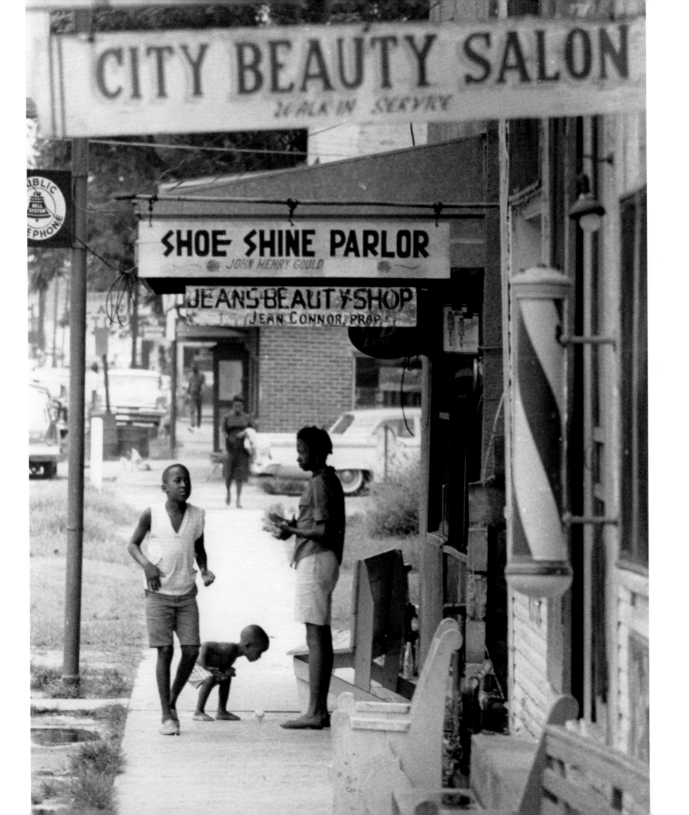

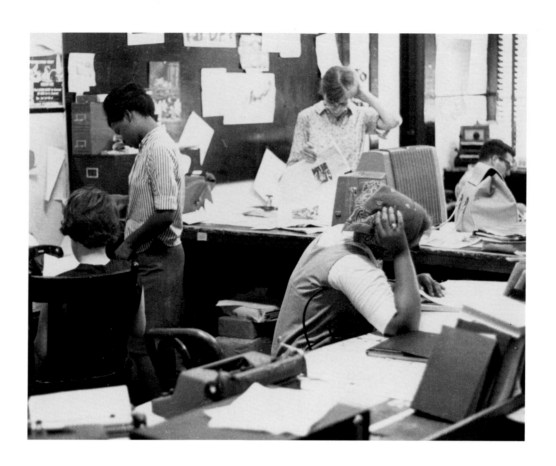

COFO-Hattiesburg Project office in the Woods Guest House at
507 Mobile Street. Left to right: Terri Shaw (Guatemala); Joyce
Brown; Nancy Ellin (Michigan); Sheila Michaels (New York City).

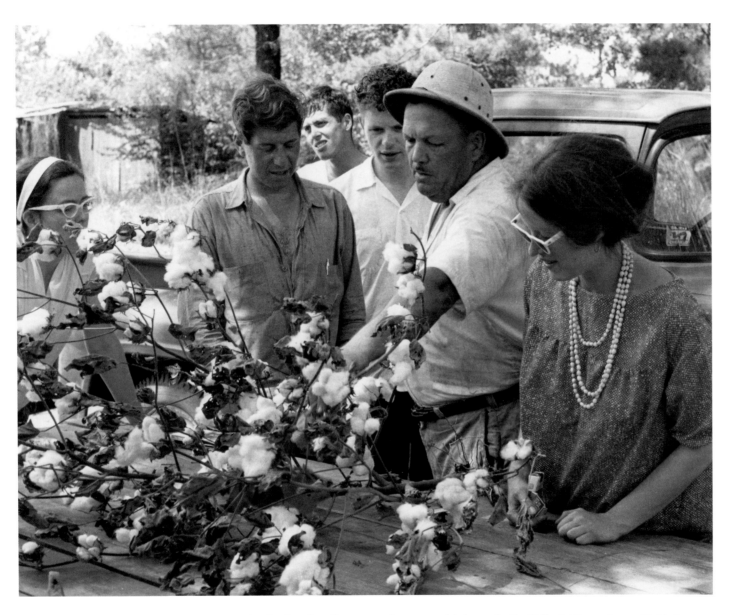

Vernon Dahmer's Independence Day picnic for the Freedom Summer volunteers at his home in the Kelly Settlement near Hattiesburg. From right: Susan Patterson (Minnesota), Vernon Dahmer, Peter Werner (Michigan). Dahmer is showing a cotton plant to the northern volunteers.

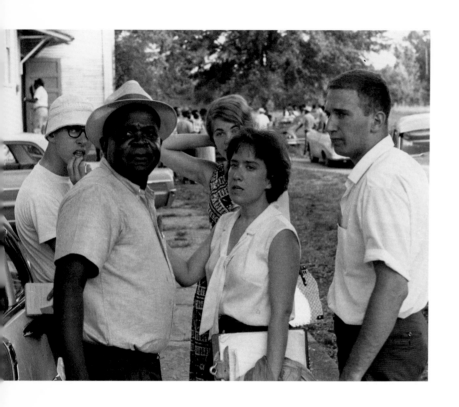
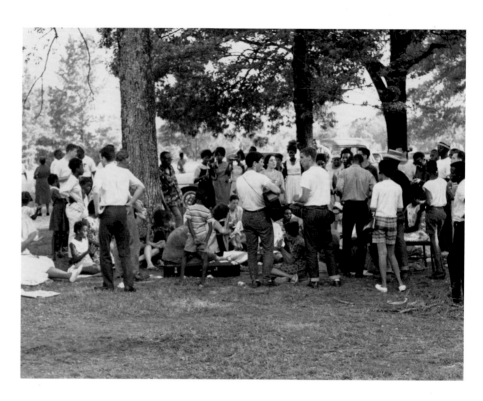

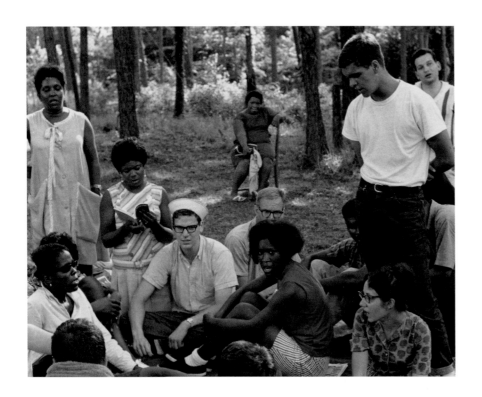

Opposite, left: Vernon Dahmer's Independence Day picnic. From left: Bob "Soda Pop" Ehrenreich? (New York), J. C. Fairley (Hattiesburg), Patricia von Yorck (Berlin; New York), Terri Shaw (Guatemala), and Doug Tuchman (New York City).

Opposite, right: Freedom Summer volunteers and local activists at Vernon Dahmer's Independence Day picnic

Left: Freedom Summer volunteers and local activists at Vernon Dahmer's Independence Day picnic. Those pictured include Marie and Sandra Blalock (Hattiesburg), "Big Daddy," Bob "Soda Pop" Ehrenreich? (New York), Stanley Zibulsky (New York), and Addie Ruth White Evans (Hattiesburg).

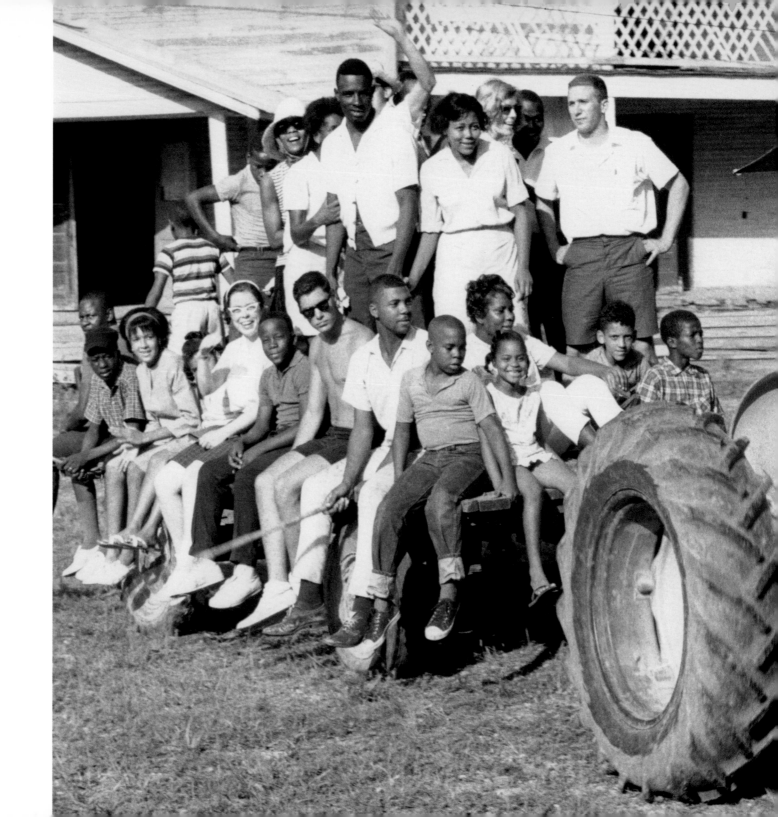

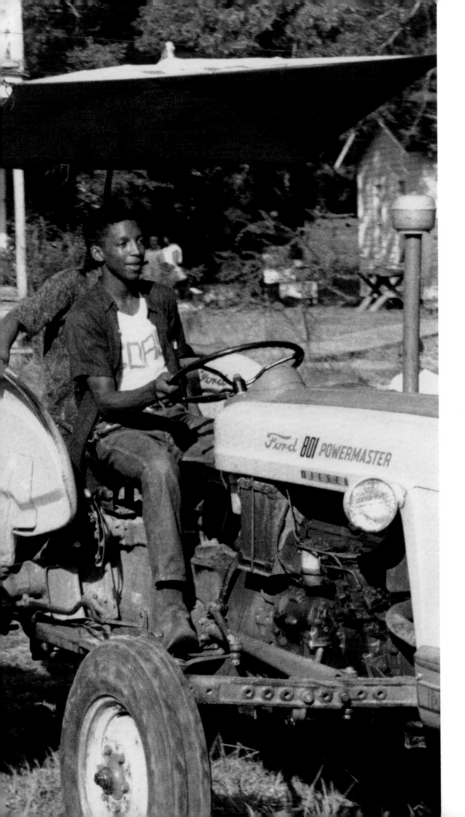

Vernon Dahmer's Independence Day picnic. Driving the tractor: Doug Smith (Hattiesburg). Standing at the front of the flat bed are Yvonne Connor (Hattiesburg) and, on her left, volunteer Doug Tuchman (New York City).

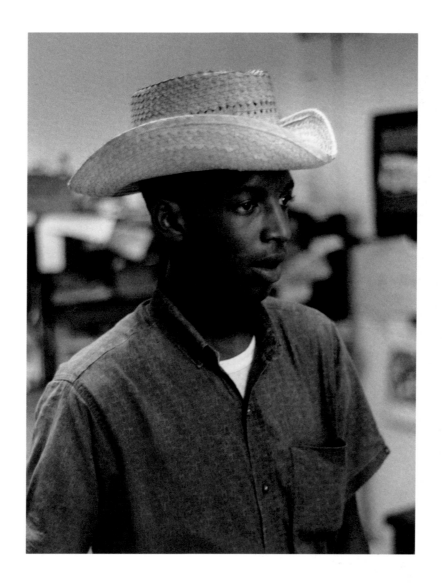

Doug Smith, youth coordinator of the COFO-Hattiesburg Project

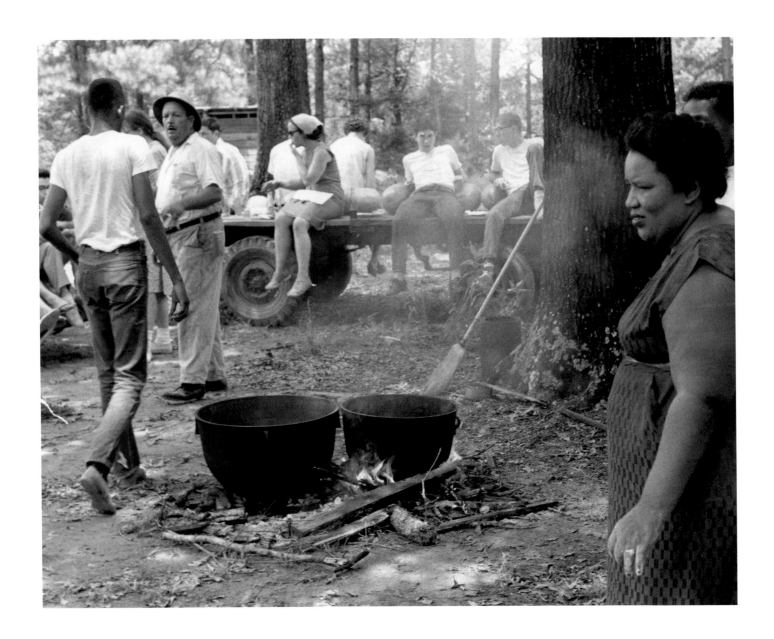

Vernon Dahmer's Independence Day picnic. Dahmer cooked lots of fried fish in iron pots for the volunteers. In pith helmet: Vernon Dahmer. Far right: Addie Ruth White Evans.

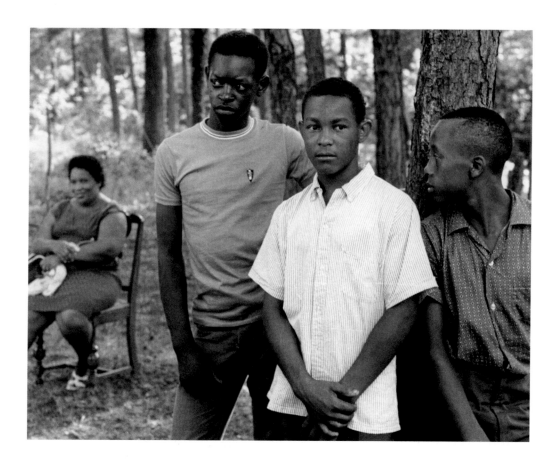

Vernon Dahmer's Independence Day picnic. The anxiety on
the faces of the young men reflects fear of retribution from the
segregationists. Far left: Addie Ruth White Evans. The young
men are from the Ducksworth, Harris, and Taylor families.

Opposite: Automobile in which Herbert Randall, covered with
blankets during daylight, rode from Oxford, Ohio to Hattiesburg,
Mississippi. The volunteer points to bullet holes in the grille.

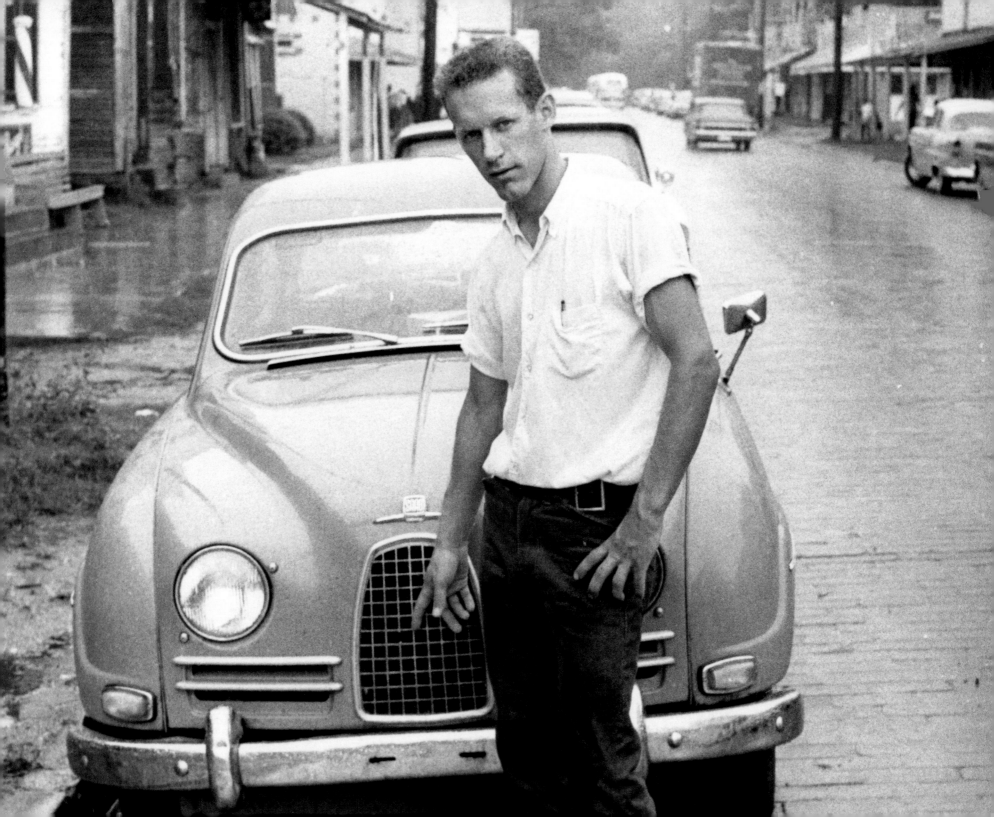

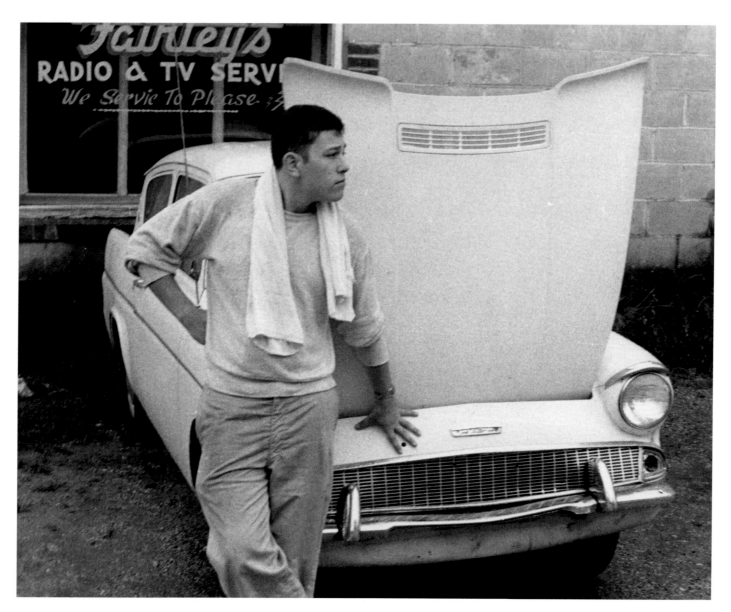

Volunteer with second automobile damaged by gunfire. The
shop is that of J. C. Fairley in the Negro Masonic Lodge building
at 522 Mobile Street.

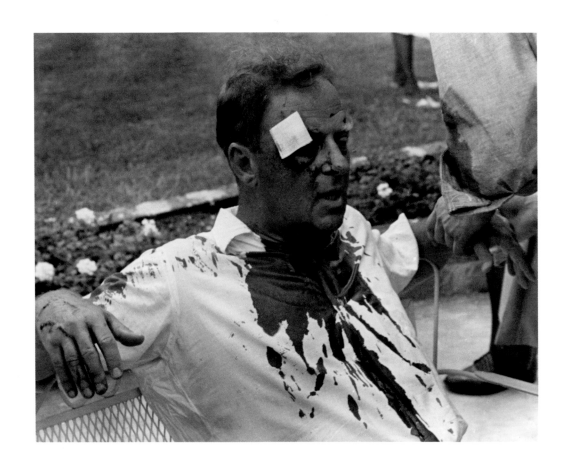

Rabbi Arthur J. Lelyveld (Cleveland, Ohio), who came to
Hattiesburg to assist with voter registration, after he had been
beaten with a tire iron

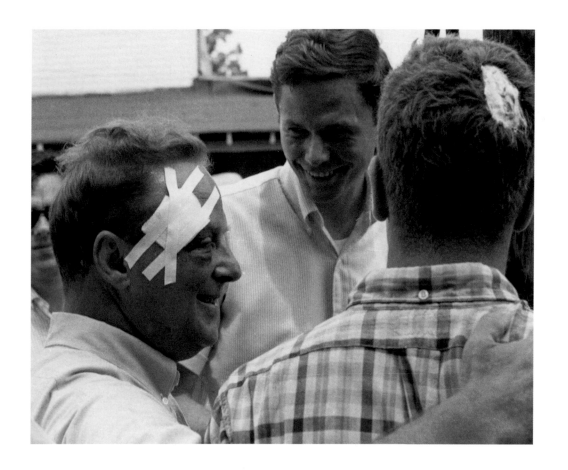

Rabbi Arthur J. Lelyveld, minister in the Hattiesburg Ministers
Project, with volunteers Lawrence Spears and David Owen
(both from California), who were beaten along with the rabbi

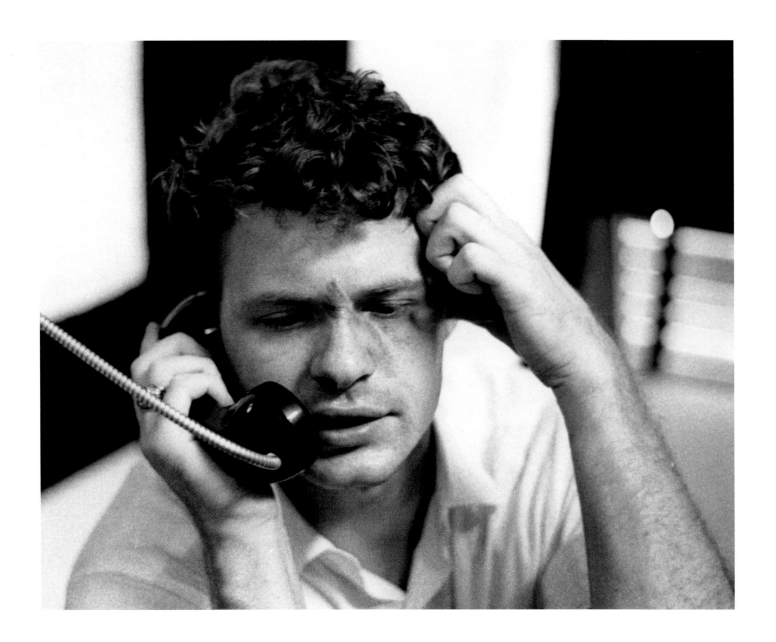

Freedom School teacher Peter Werner after being assaulted by a segregationist

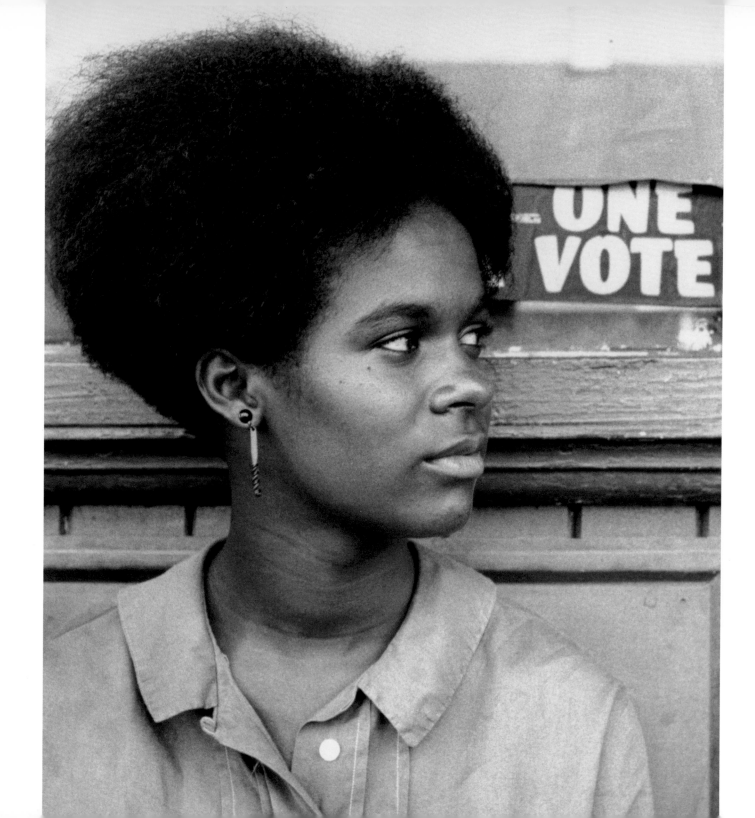

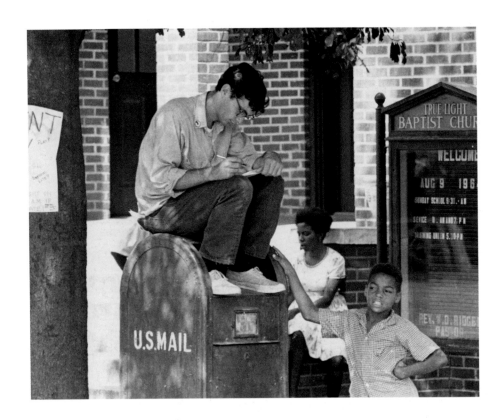

Opposite: Local activist Gracie Hawthorne in front of SNCC's "One Man, One Vote" sign at COFO headquarters at 507 Mobile Street

Above: Volunteer Anthony "Arrow" Beaulieu in front of True Light Baptist Church, located in 1964 at 1101 Dewey Street near Mobile Street

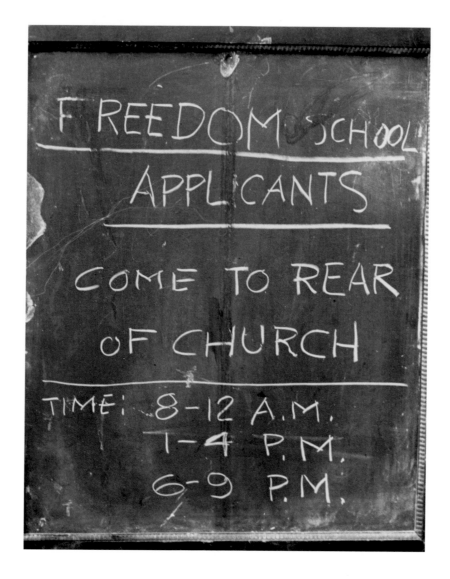

Sign announcing Freedom School registration

Opposite: Freedom School students. The child facing the
camera is Jerry Lewis Oatis.

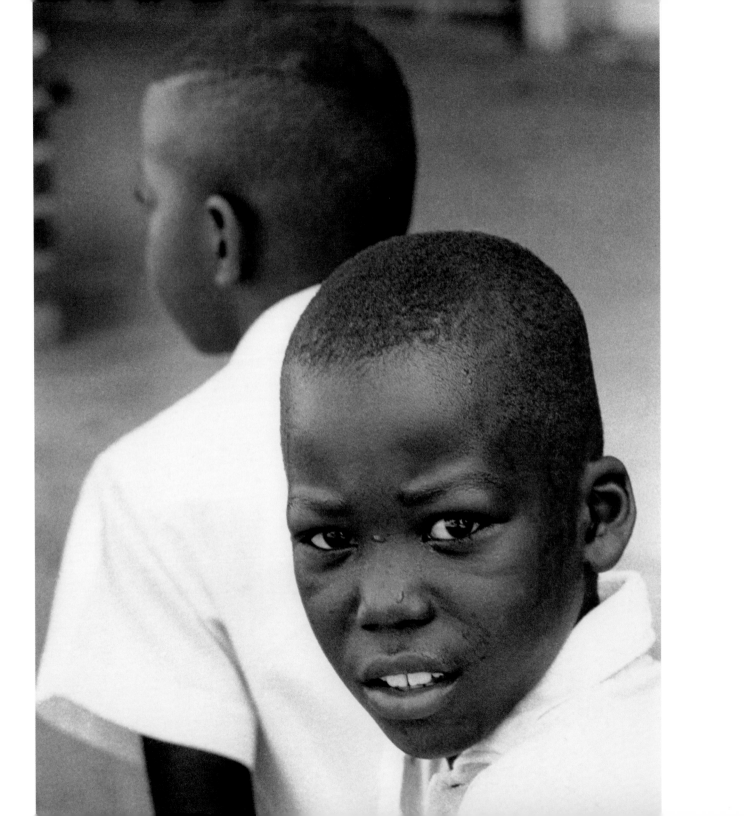

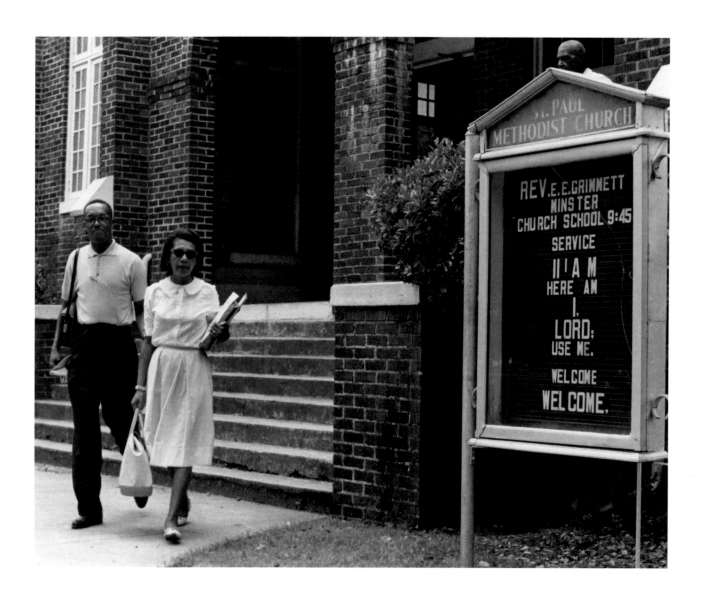

Freedom School coordinators Arthur and Carolyn Reese
(Detroit, Michigan) in front of St. Paul United Methodist
Church, located at 215 East 5th Street near Mobile Street

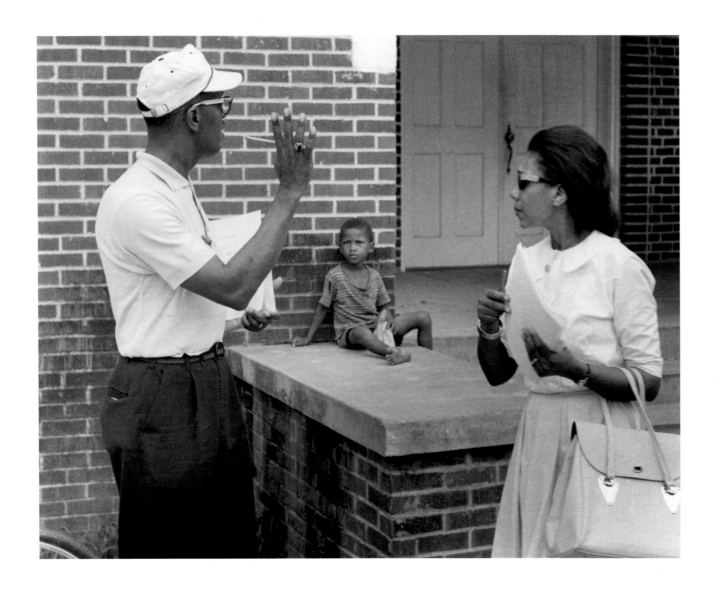

Arthur and Carolyn Reese with "Little Jimmy" at Mt. Zion Baptist
Church, located in 1964 at 901 Spencer Street

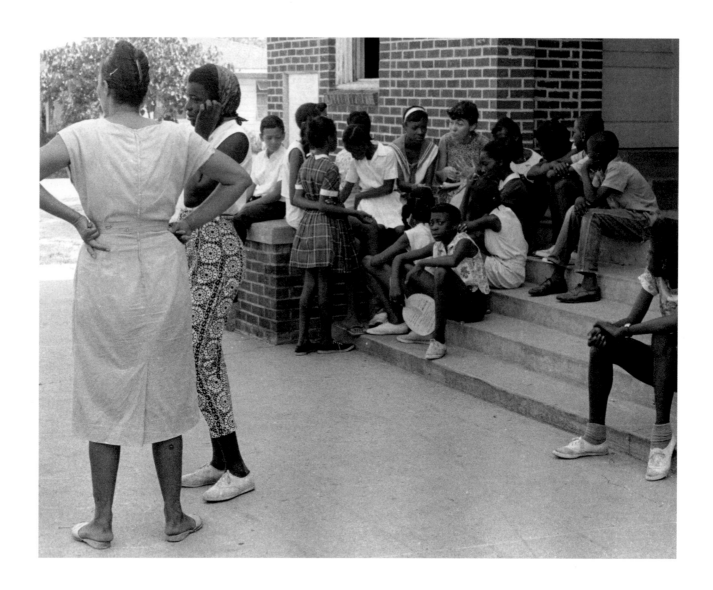

Freedom School class meeting outdoors at Mt. Zion Baptist Church

Opposite: Freedom School class at Mt. Zion Baptist Church. The
girls include Gwen Bourne, Deborah Carr, and Shirley Funchess.

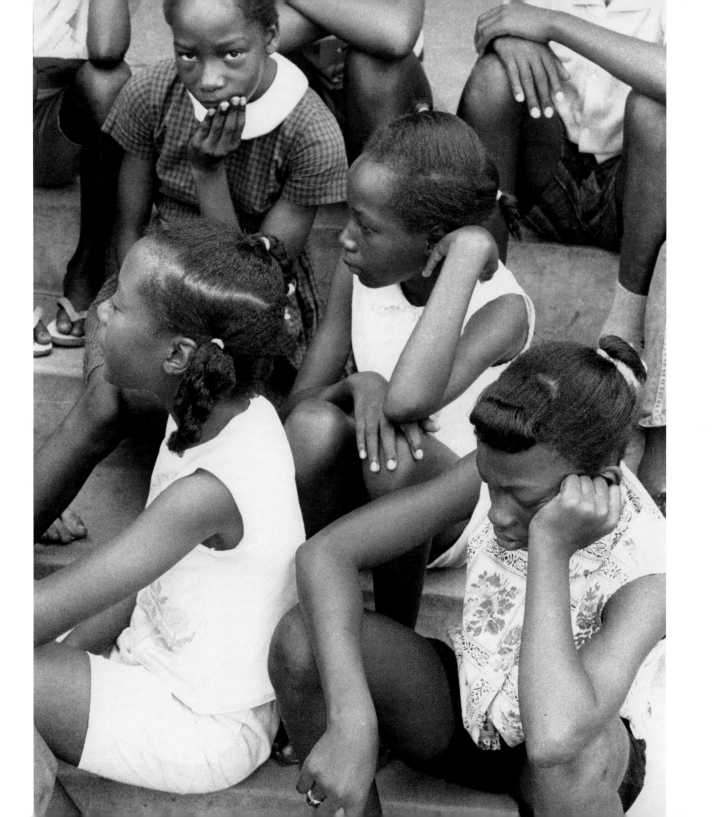

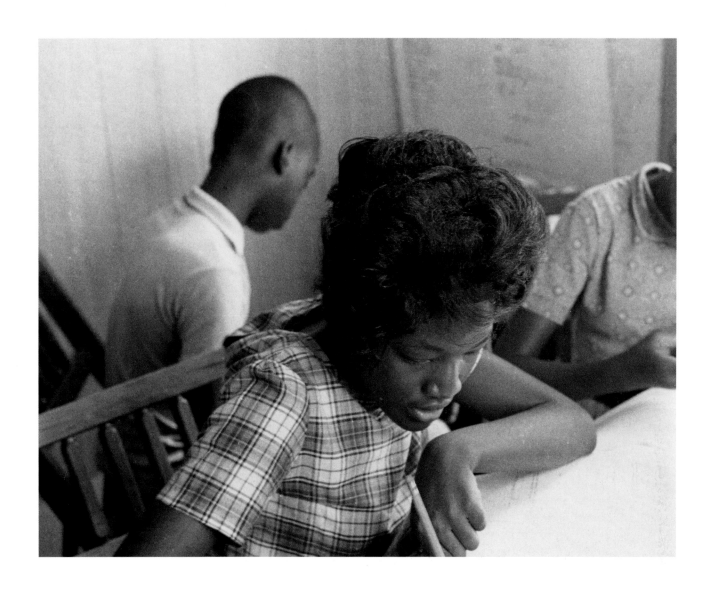

Freedom School students Margaret Dwight (center) and Alice Dwight

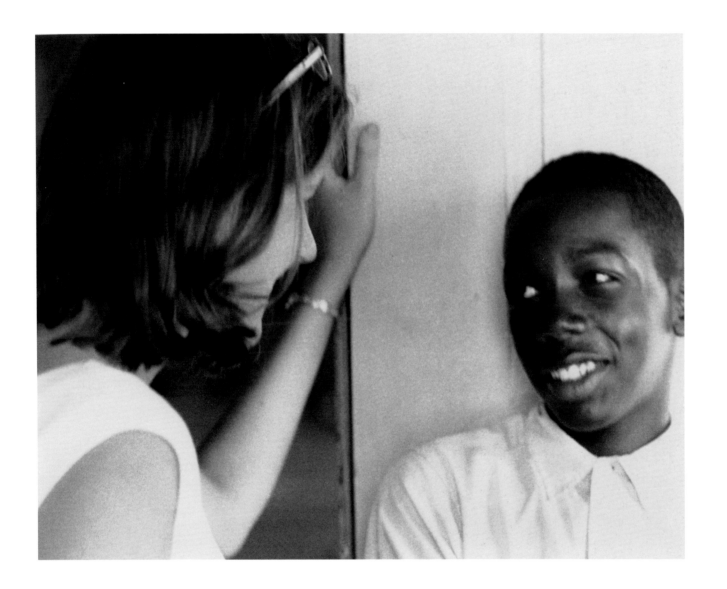

Freedom School teacher Paula Pace and one of her students

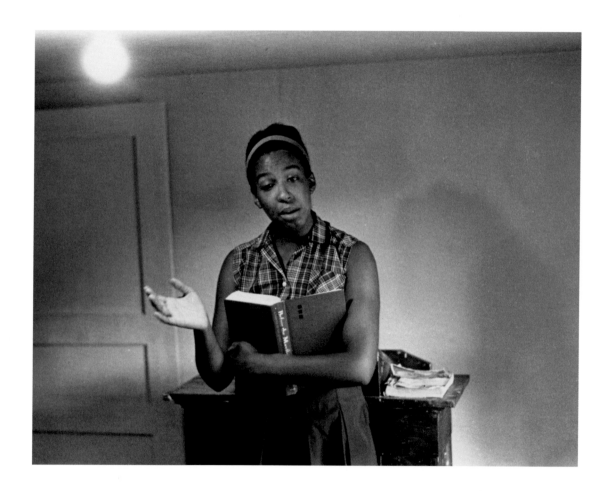

Denise Jackson, a Freedom School teacher from New York

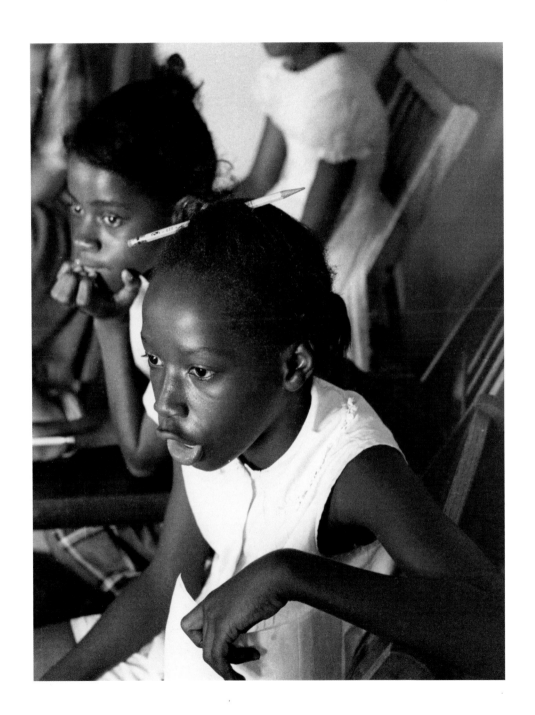

Freedom School students at
Mt. Zion Baptist Church

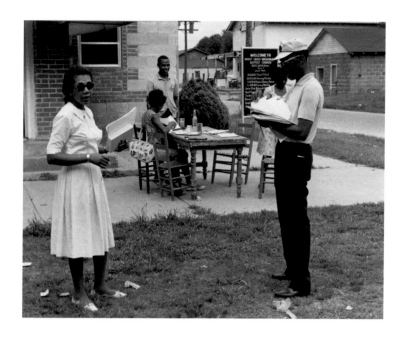

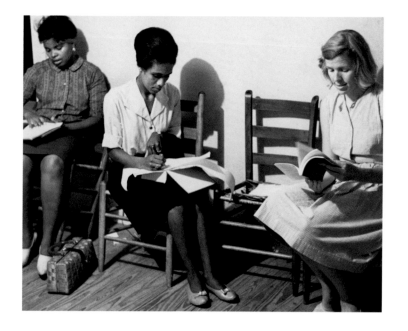

Above: Carolyn and Arthur Reese during Freedom School registration at Priest Creek Missionary Baptist Church in Palmer's Crossing

Left: Freedom School students Ethel Murrell Stokes and Teresa Clark with their teacher, Sandra Adickes (New York City), at Priest Creek Missionary Baptist Church

Opposite: Freedom School student Lillie Dwight

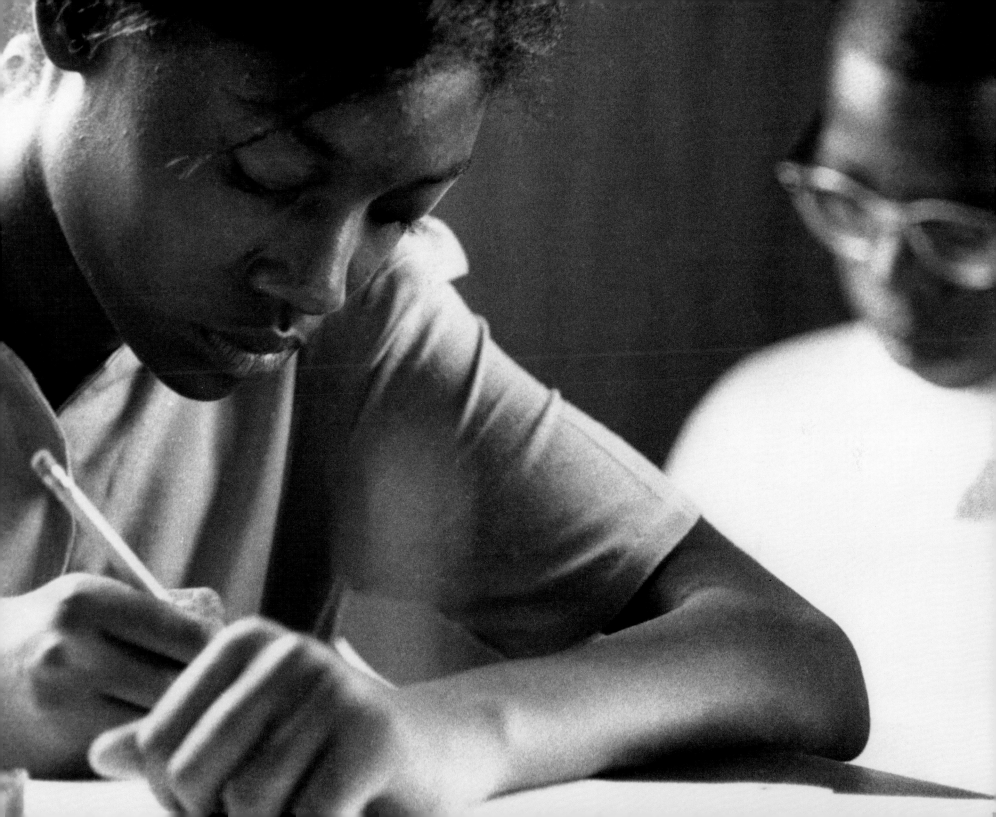

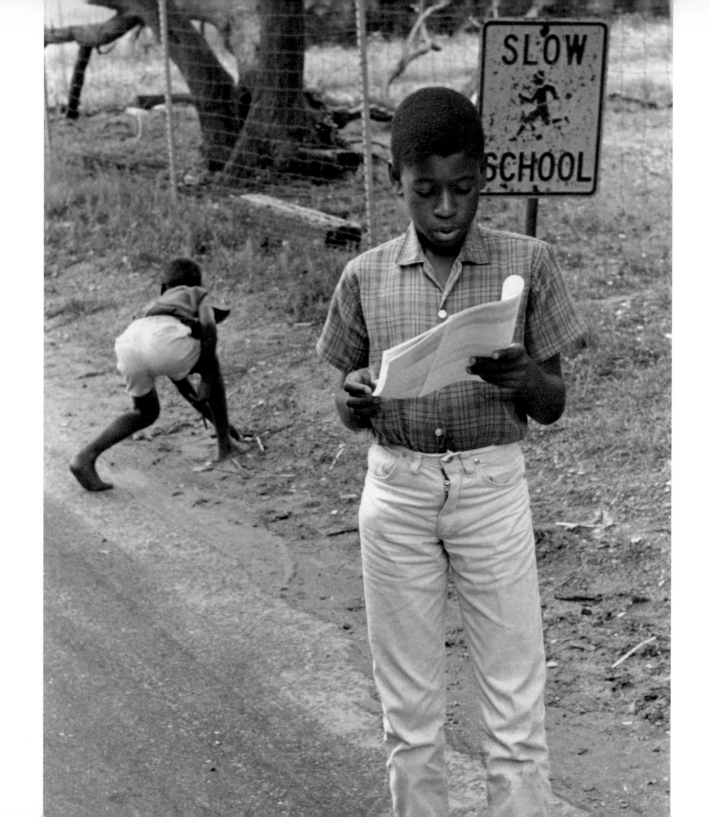

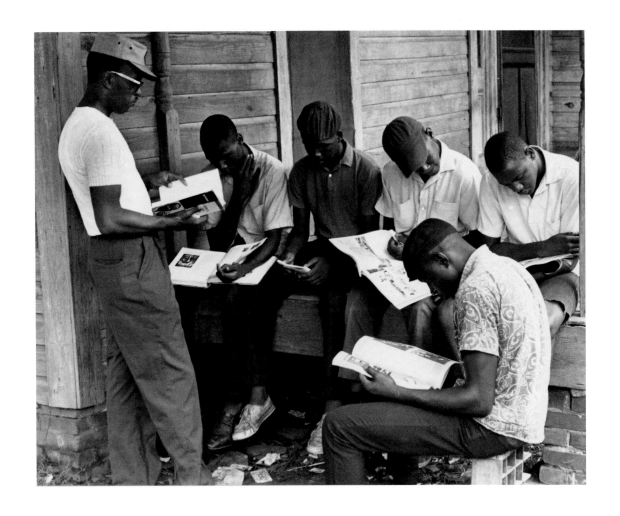

Opposite: Freedom School students

Above: Arthur Reese with Freedom School students reading
Ebony magazine, which many of them had never seen before

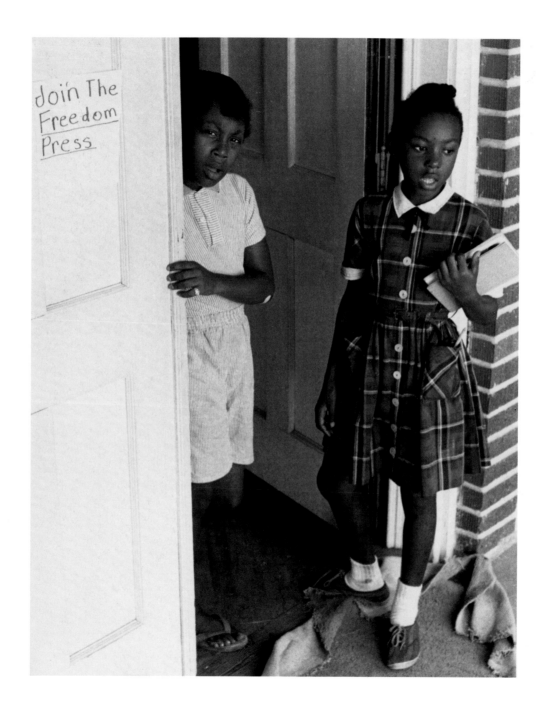

Freedom School students at
Mt. Zion Baptist Church

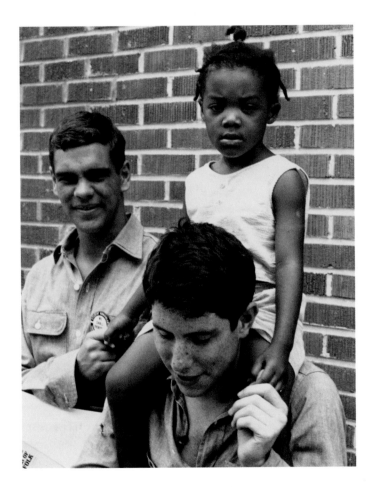

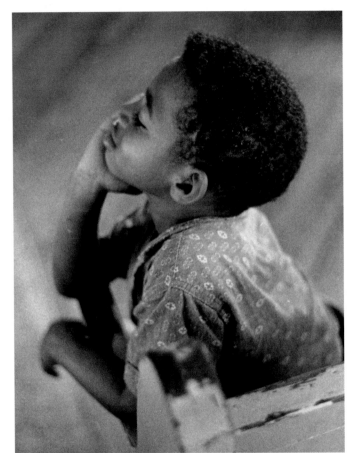

Cynthia Beard sitting on the shoulders of volunteer
Jacob Blum (Yale University)

Freedom School student

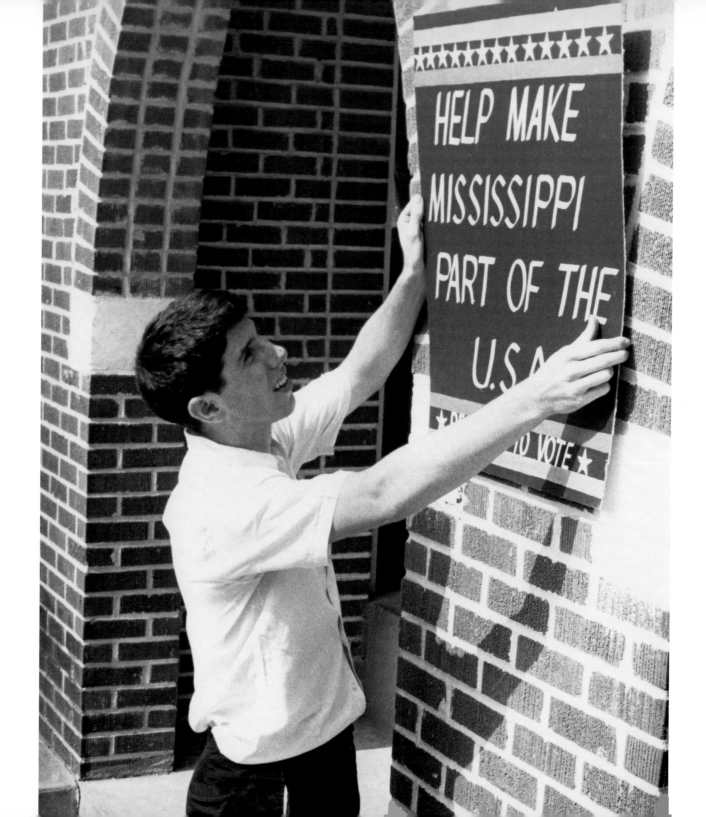

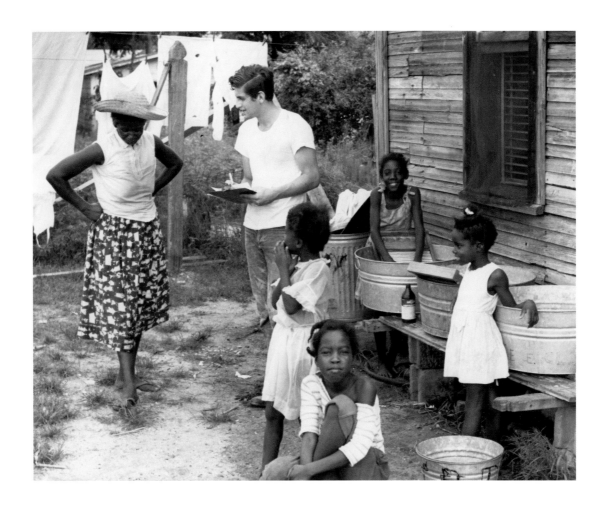

Opposite: Volunteer Jacob Blum preparing for Mississippi Freedom
Democratic Party registration at Mt. Zion Baptist Church

Above: Voter registration canvassing of local resident Hattie Mae
Pough by volunteer Dick Landerman (Duke University)

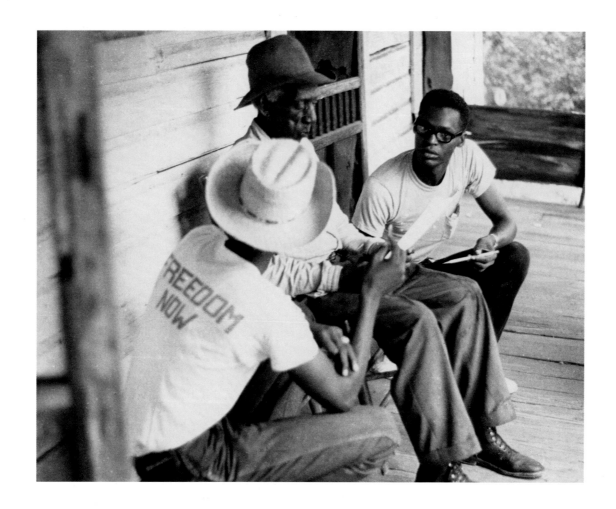

Voter registration canvassing of local resident Felix Smith by
Doug Smith (back to camera) and COFO-Hattiesburg director
Sandy Leigh

Opposite: Voter registration canvassing of local resident Felix
Smith by Sandy Leigh

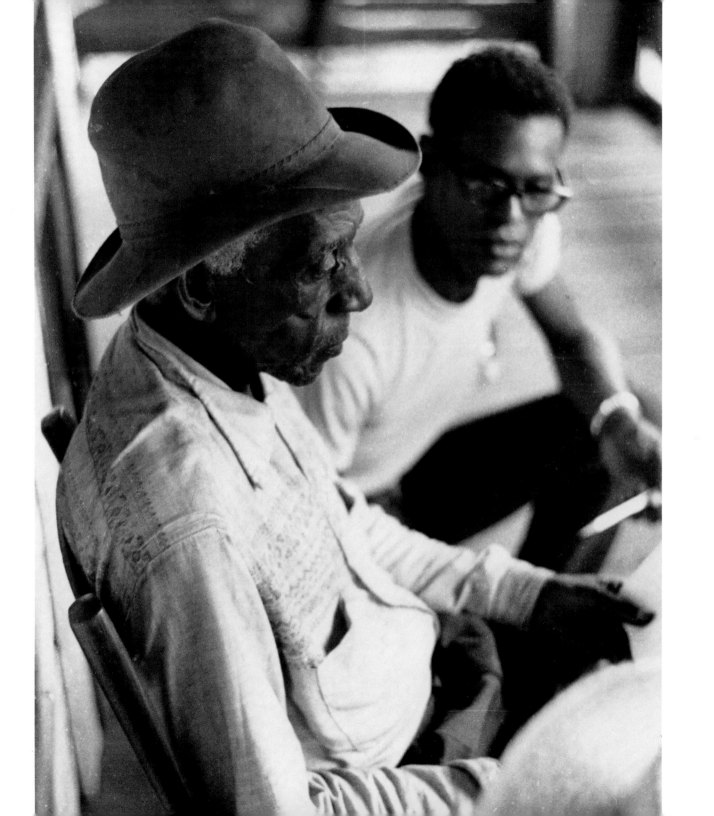

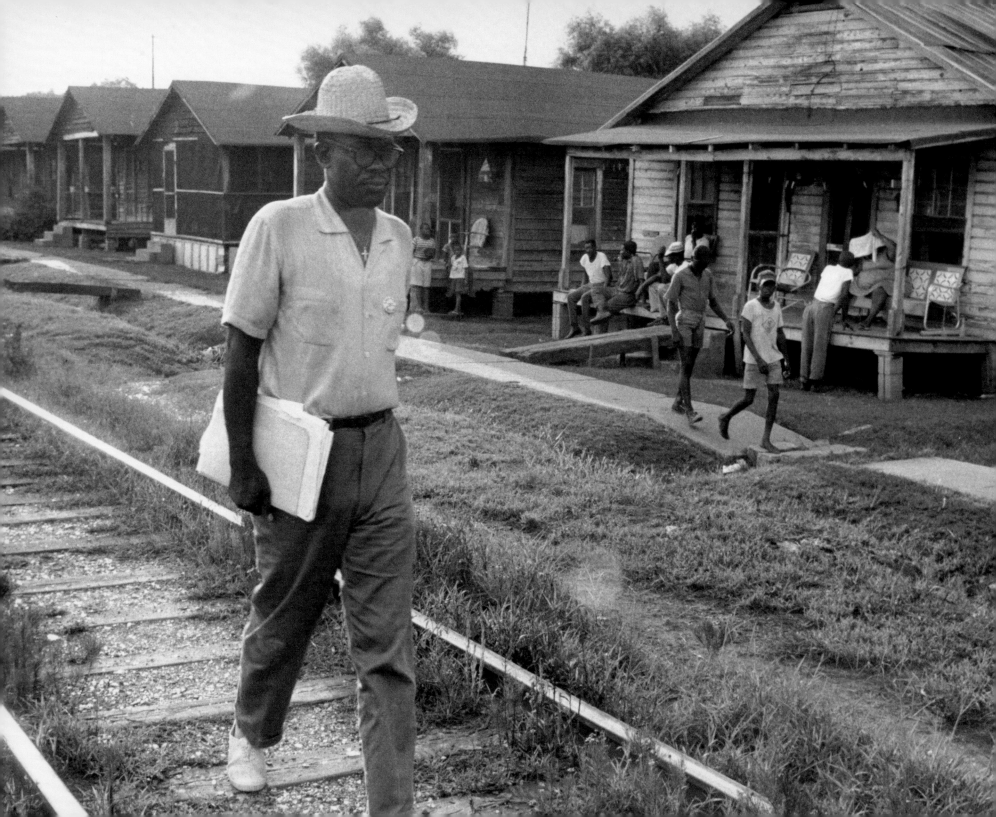

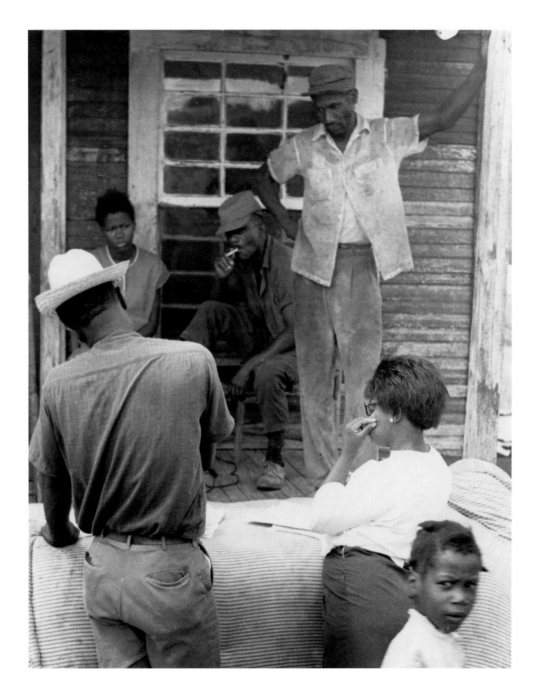

Opposite: Volunteer Jim Nance, a minister, heading into the black community to do voter registration canvassing near the intersection of Fifth and Mobile Streets

Right: Voter registration canvassing of local residents by volunteer Rev. Jim Nance

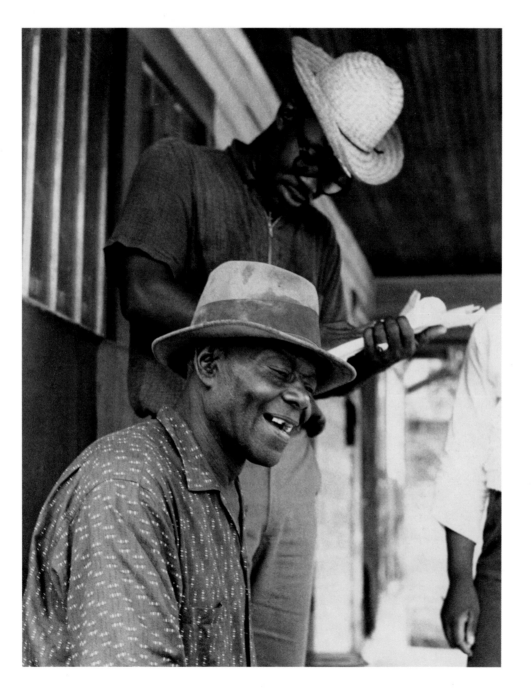

Voter registration canvassing of local
resident by volunteer Rev. Jim Nance

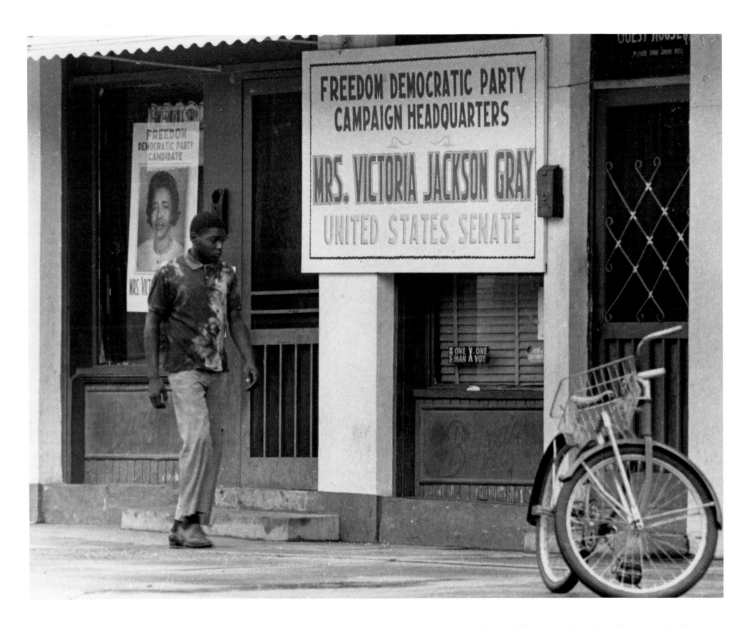

Victoria Jackson Gray's Mississippi Freedom Democratic Party
headquarters at 507 Mobile Street during her campaign for the
U.S. Senate

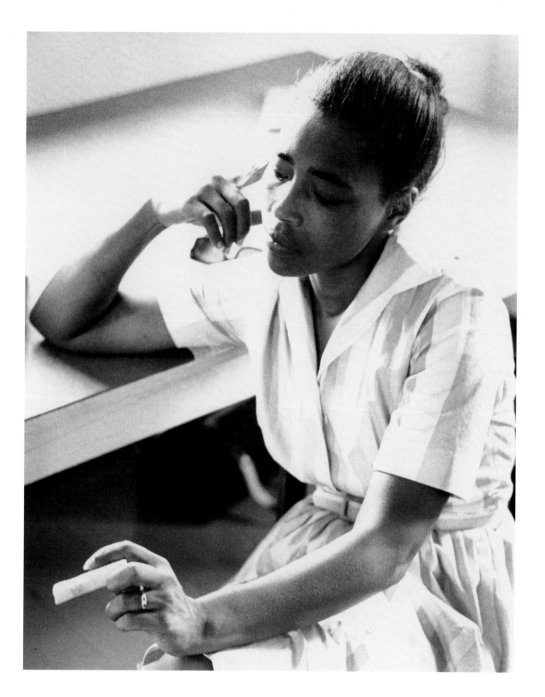

Victoria Jackson Gray
(Palmer's Crossing and
Hattiesburg, Mississippi)

Mississippi Freedom Democratic
Party sign with a sign offering
menial jobs in the North

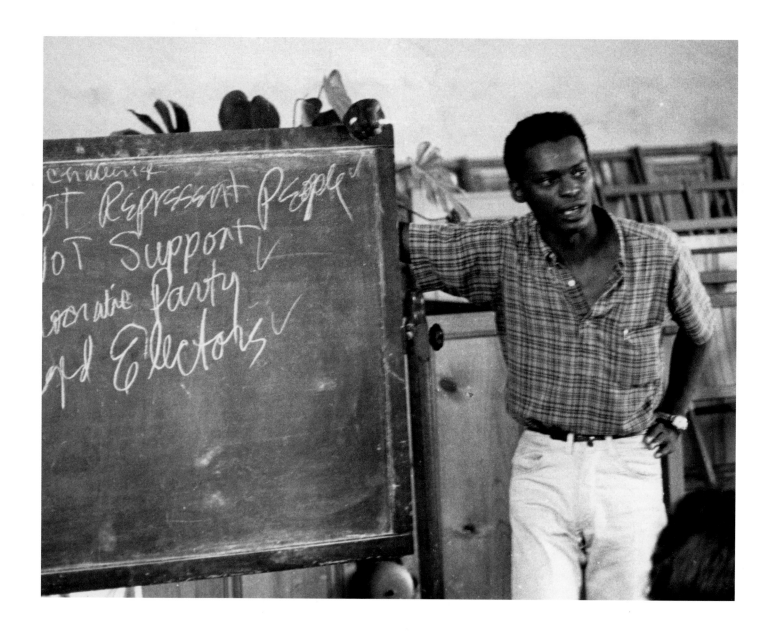

COFO-Hattiesburg direcror Sandy Leigh leading a political workshop at True Light Baptist Church

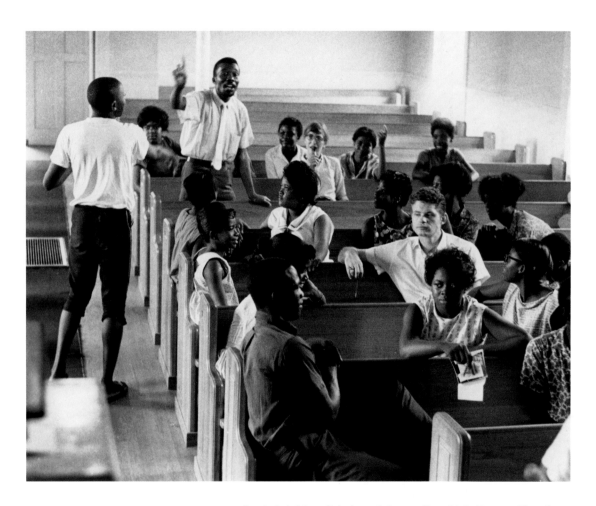

Sandy Leigh's political workshop at True Light Baptist Church. In the audience are local residents Sandra Blalock, Ann Conner, Audrey and Myrtis Eastland, James Townes, Janice Walter, Shirley White, and Jerry Wilson and volunteers Nancy Ellin, William D. Jones (standing at his seat in the pew), and Peter Werner.

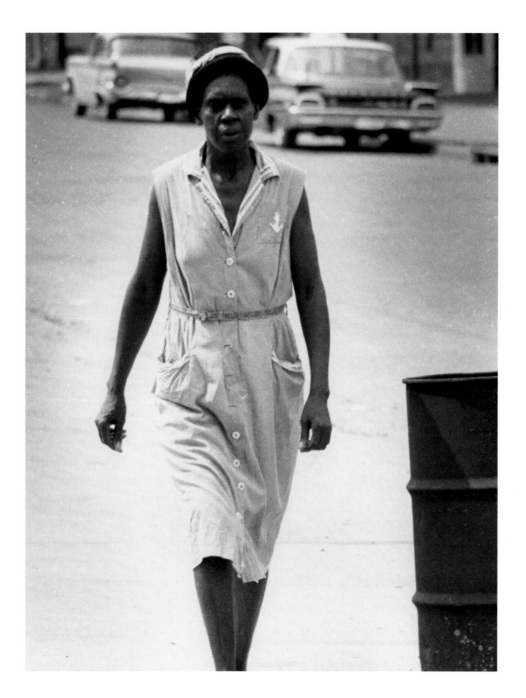

Local activist Levater Jackson
walking down Mobile Street

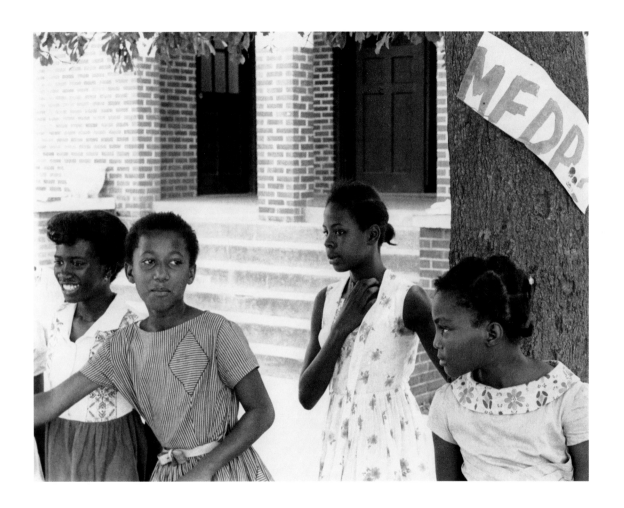

Freedom School students Joyce McGowan, Latha Collins,
Veronica Carter, and Daneeta Walker in front of True Light
Baptist Church

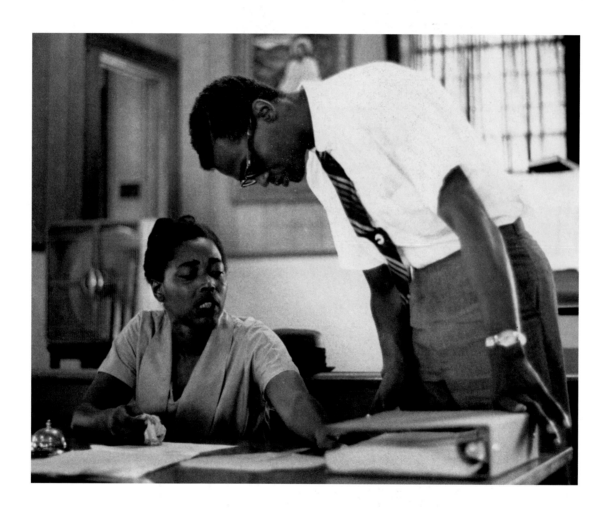

Victoria Jackson Gray and Sandy Leigh at St. John United
Methodist Church in Palmer's Crossing

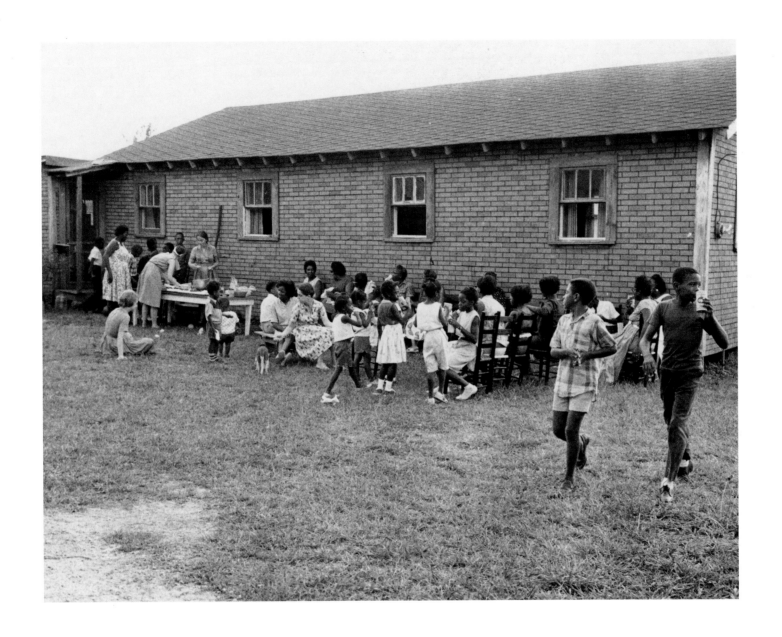

Celebration of the opening of the Palmer's Crossing
Community Center

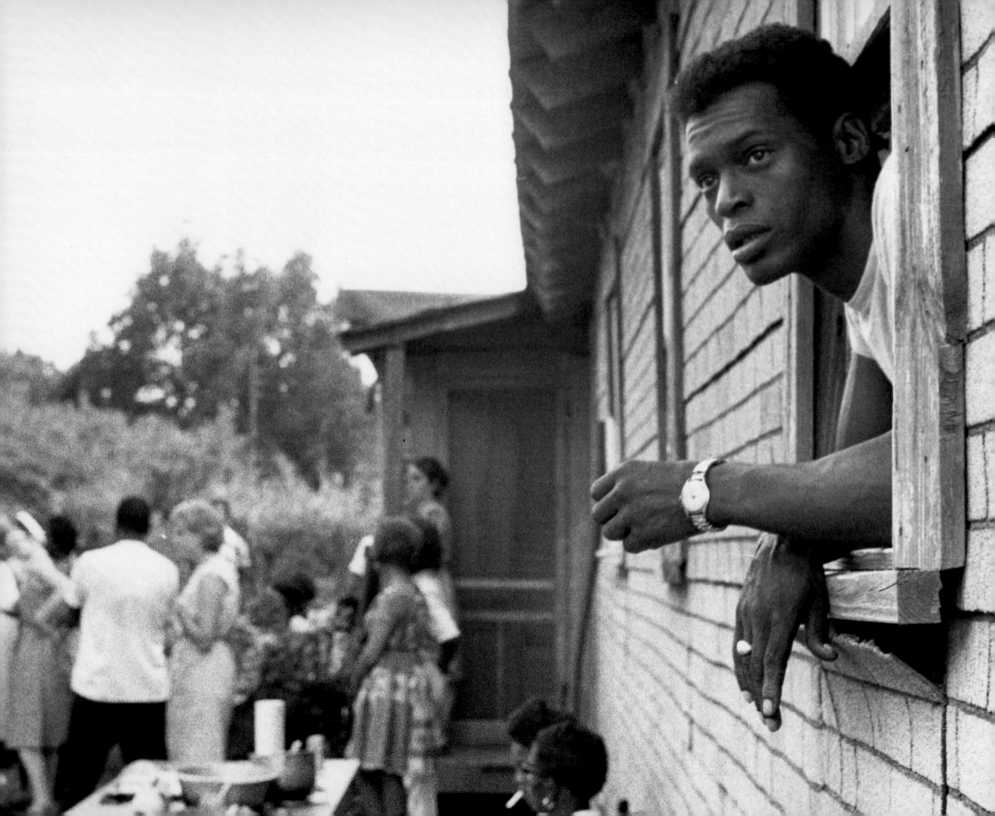

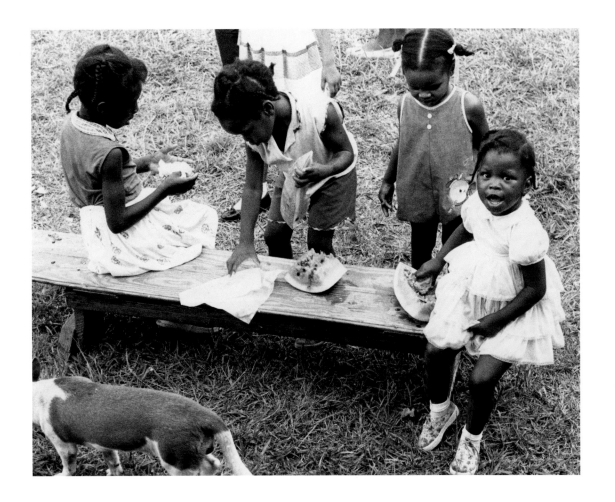

Opposite: COFO-Hattiesburg director Sandy Leigh at the opening
of the Palmer's Crossing Community Center

Above: Children helping celebrate the opening of the Palmer's
Crossing Community Center

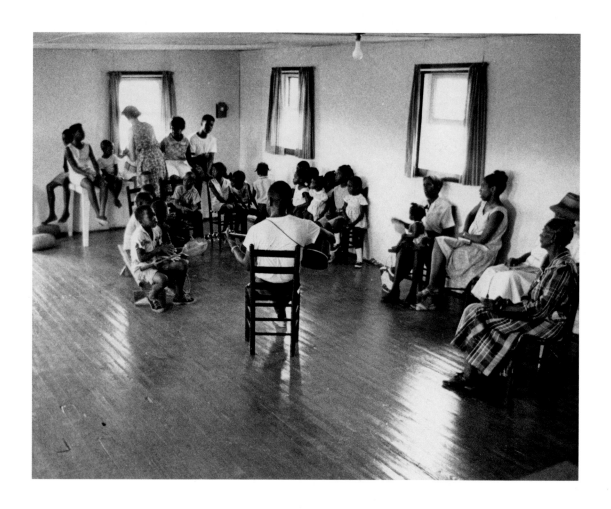

Folksinger "Folksy" Joe Harrison (Detroit, Michigan) entertaining
children at the opening of the Palmer's Crossing Community Center

Opposite: Freedom School Library, Palmer's Crossing Community Center

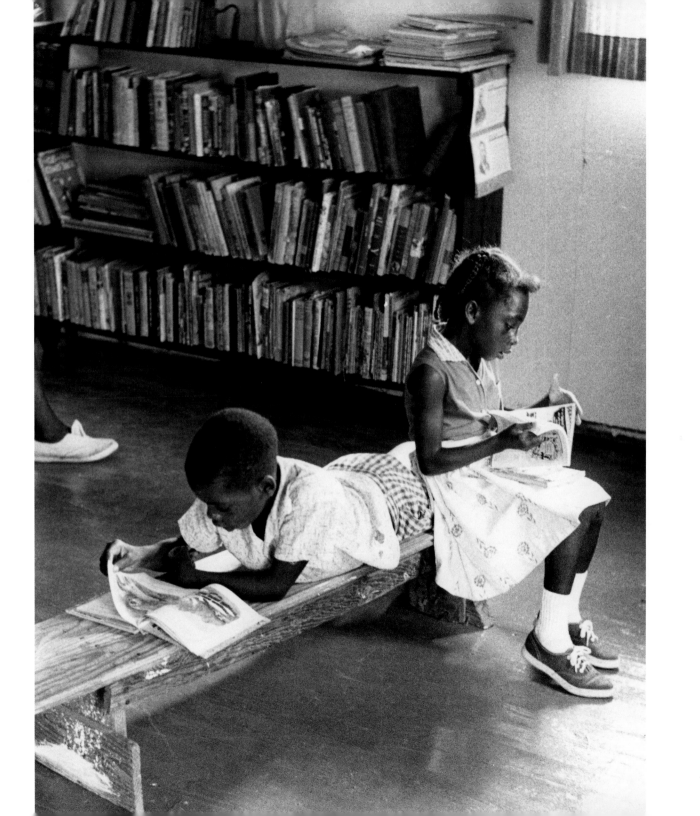

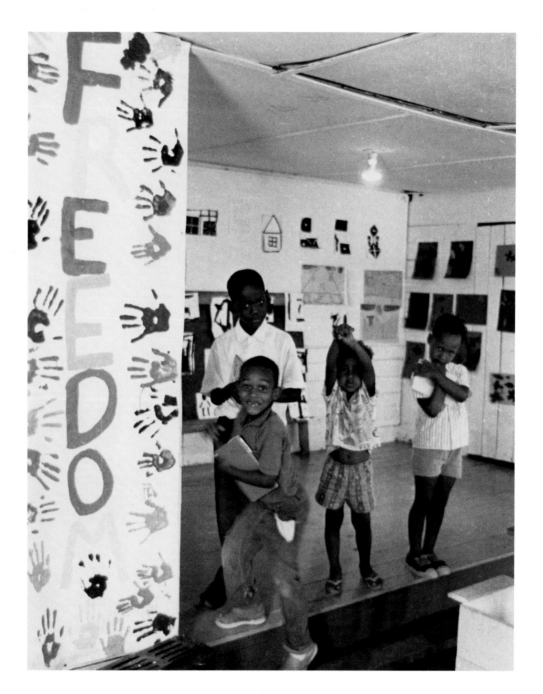

Freedom School students and their works of art, Palmer's Crossing Community Center

Above: Children of Hattiesburg on Dewey Street

Left: Children of Hattiesburg

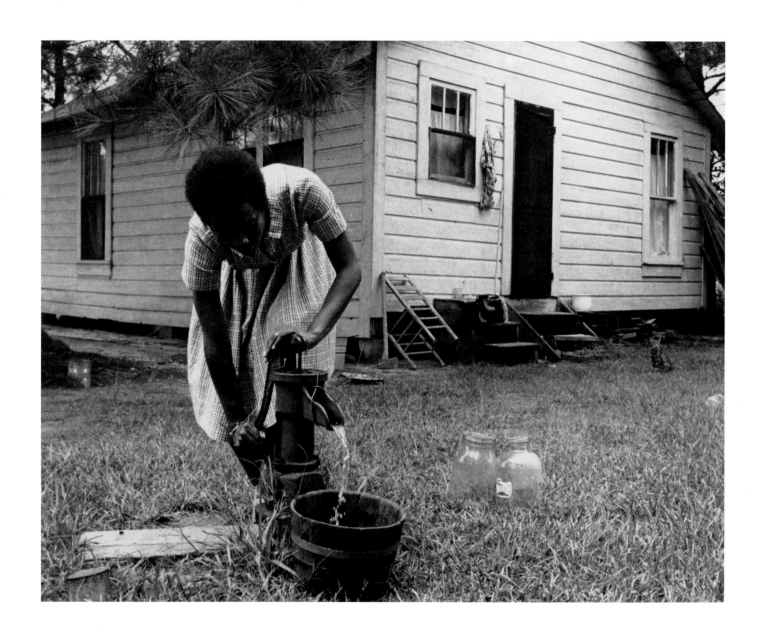

Volunteer Lorne Cress (Chicago, Illinois) pumping water in the
yard of her hostess in Palmer's Crossing

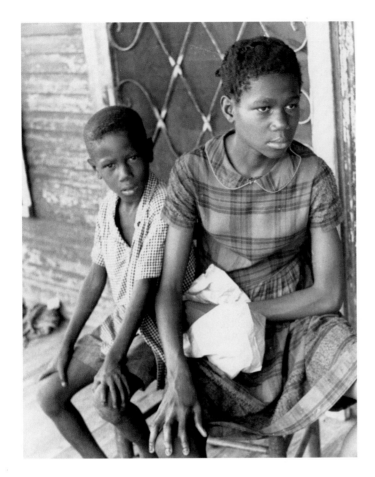

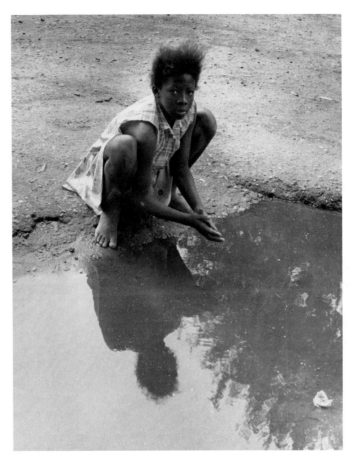

Children of Hattiesburg

Peggy Copeland, granddaughter of local activist Vassie Patton

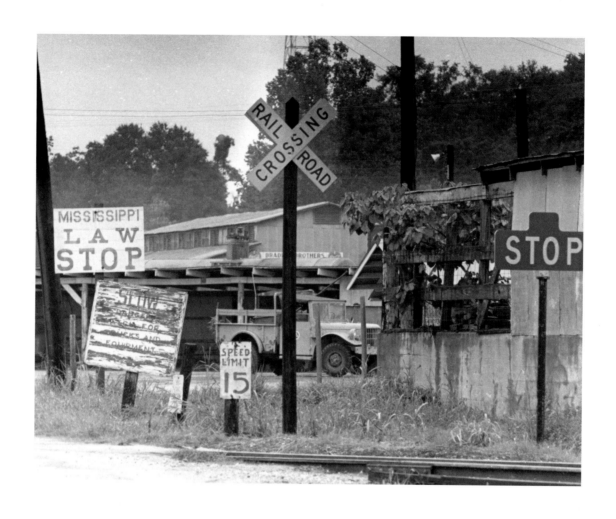

Above and opposite: Railroad crossing near the intersection of
Third and Mobile Streets, the demarcation between white
Hatttiesburg and black Hatttiesburg

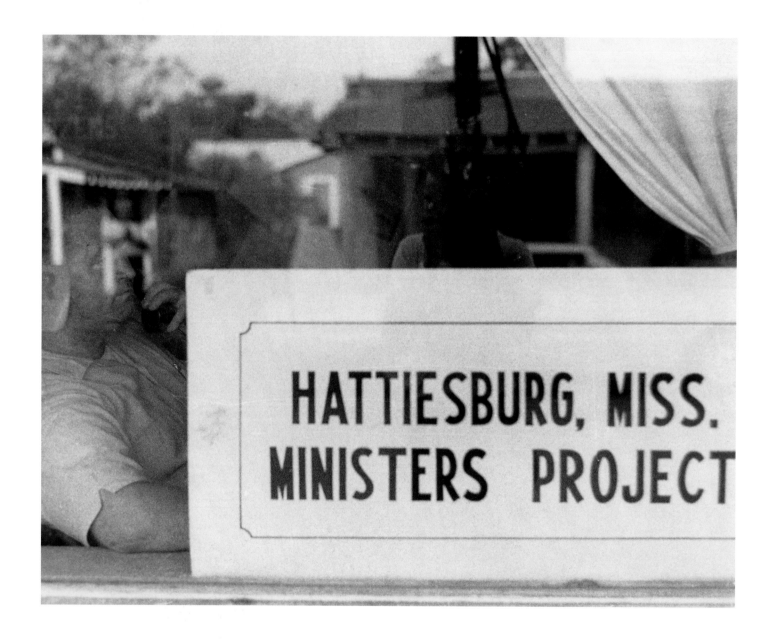

Headquarters of the Hattiesburg Ministers Project in the Negro Masonic Lodge
at Sixth and Mobile Streets. Herbert Randall is reflected in the window.

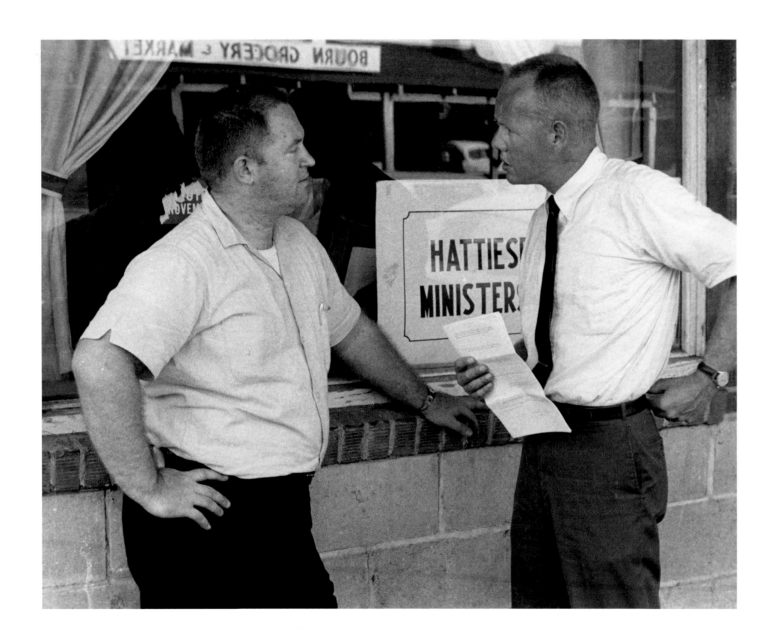

Hattiesburg Ministers Project headquarters in the Negro Masonic Lodge at Sixth and Mobile Streets. Left: project director Rev. Bob Beech (Illinois).

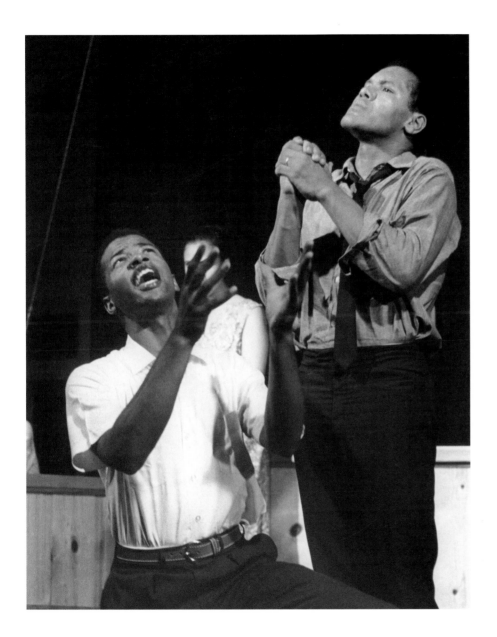

Opposite, left: The Free Southern Theater's poster announcing the performance of Martin Duberman's play *In White America*, hosted by two black churches in Hattiesburg

Opposite, right: Free Southern Theater actress Denise Nicholas, who later starred in the television series *In the Heat of the Night*

Left: Actors John O'Neal (a student at Southern Illinois University) and Gilbert Moses (New York), cofounders of the Free Southern Theater

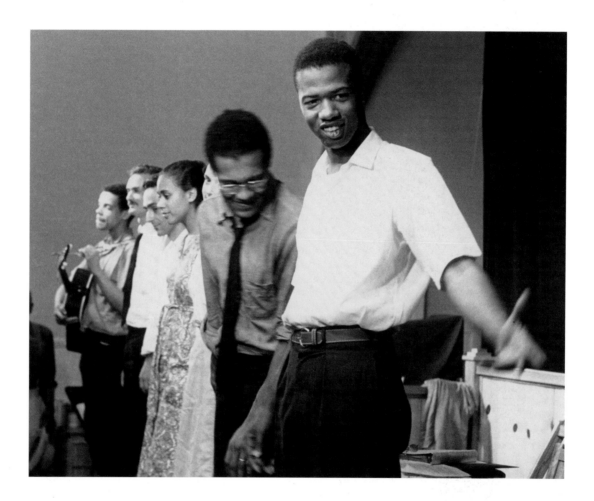

The cast of the Free Southern Theater's performance of Martin Duberman's play *In White America* taking their final bow at True Light Baptist Church. From right: John O'Neal, Gilbert Moses, Susan Tabor, Denise Nicholas, Eric Weinberger, Lester Galt, and guitarist Stu House. Far left: local activist John Gould.

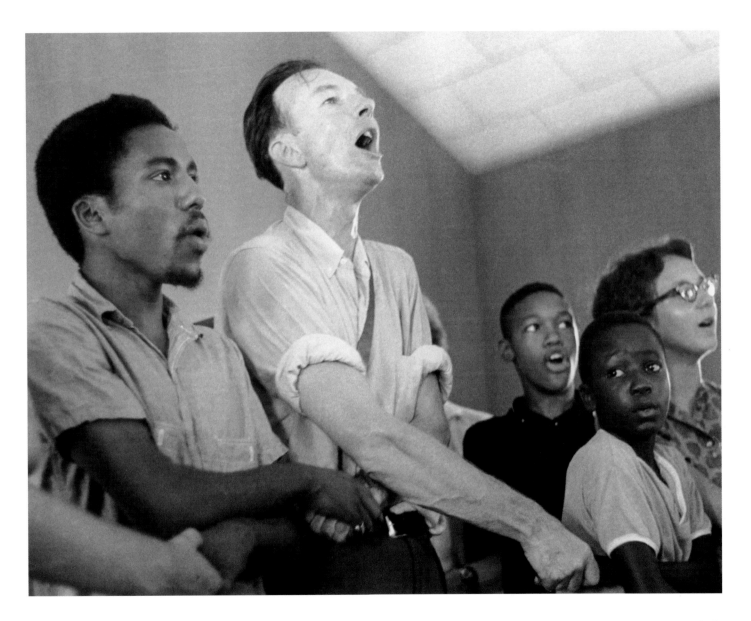

Folksingers Roger Johnson and Pete Seeger singing "We Shall Overcome" with Freedom School students at the Palmer's Crossing Community Center

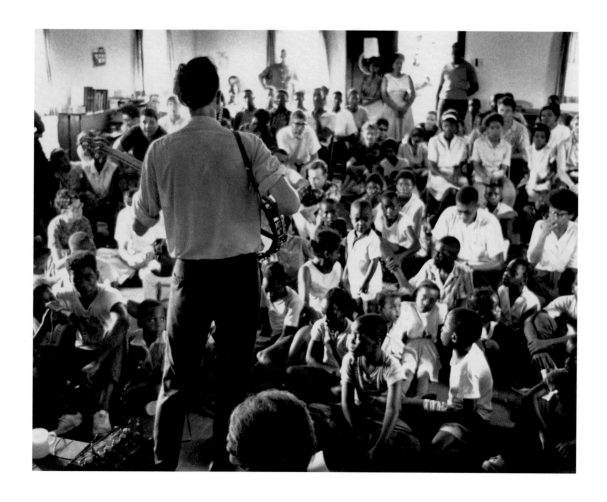

Pete Seeger performing for Freedom School students at the
Palmer's Crossing Community Center

Opposite: Freedom School students Don Luther Moore, the
Stewart sisters, and Sammy Perkins listening to folksinger
Pete Seeger at the Palmer's Crossing Community Center

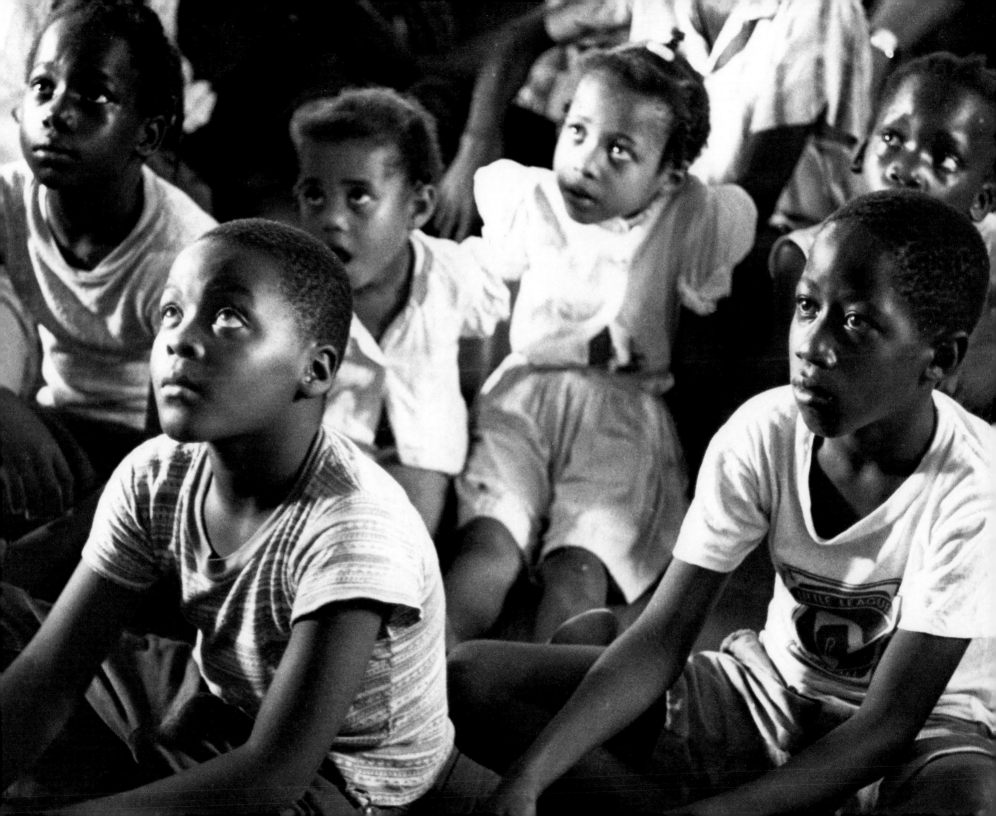

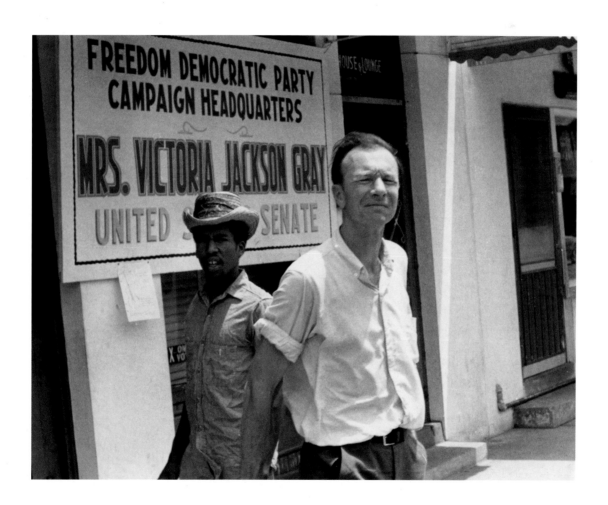

Folksingers Roger Johnson and Pete Seeger in front of Victoria
Jackson Gray's Mississippi Freedom Democratic Party headquarters

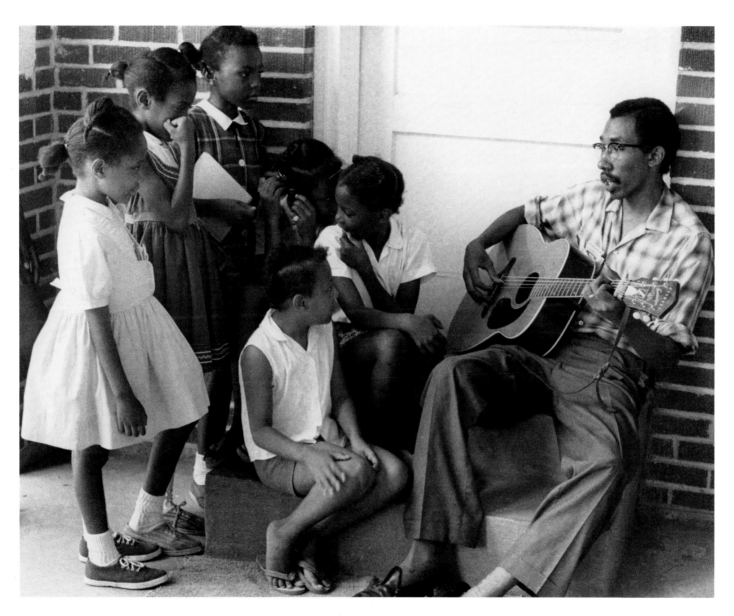

Folksinger Julius Lester (St. Louis, Missouri) performing for
Freedom School students Jessie Ann and Gloria May, Glenda
Funchess, and Valmina Blackamon at Mt. Zion Baptist Church

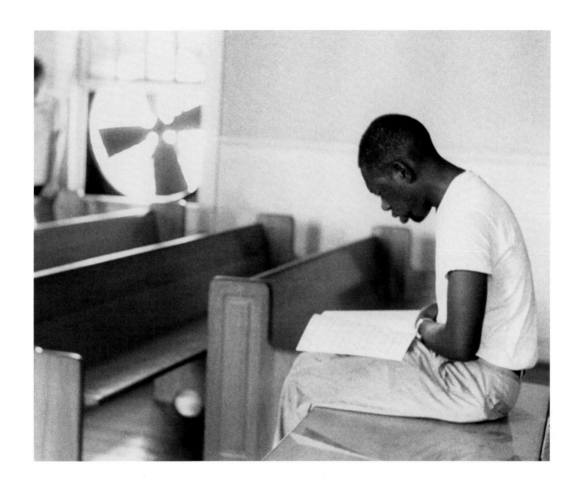

Folksinger "Folksy" Joe Harrison (Detroit, Michigan) in True
Light Baptist Church

Opposite: Folksinger demonstrating a mandolin to a Freedom
School student

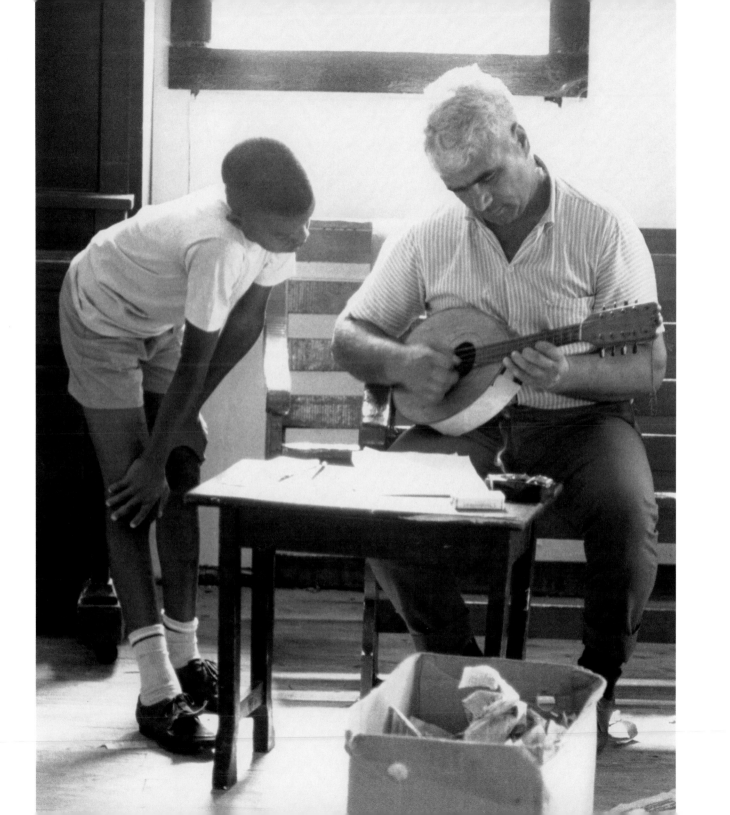

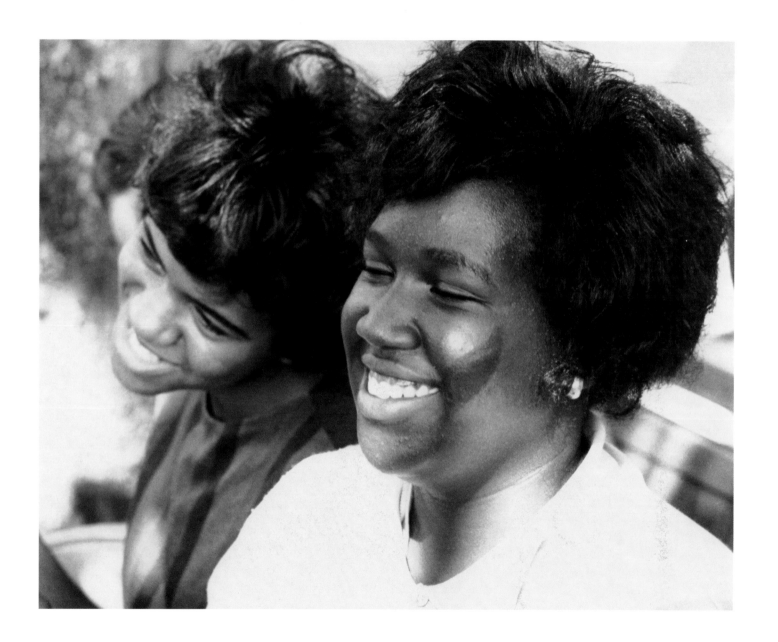

Hettie Marsh and Geraldine Shaw of Hattiesburg

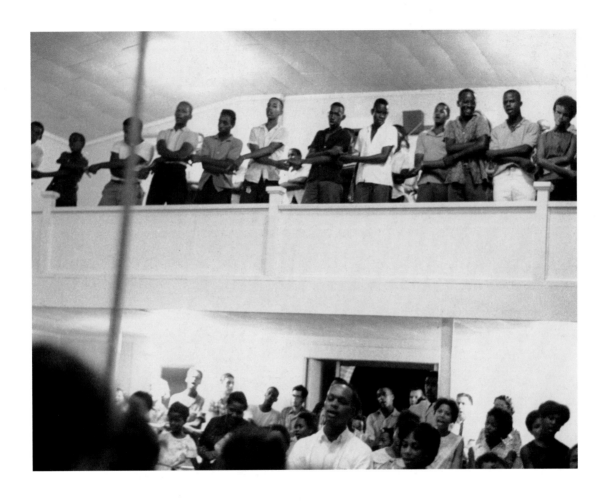

Participants singing "We Shall Overcome" in a mass meeting at
True Light Baptist Church

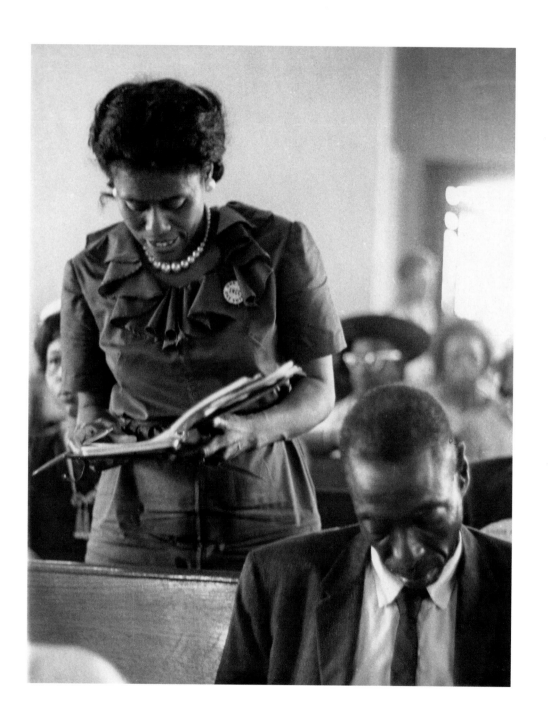

Mississippi Freedom
Democratic Party Fifth
Congressional District caucus
at St. John United Methodist
Church in Palmer's Crossing

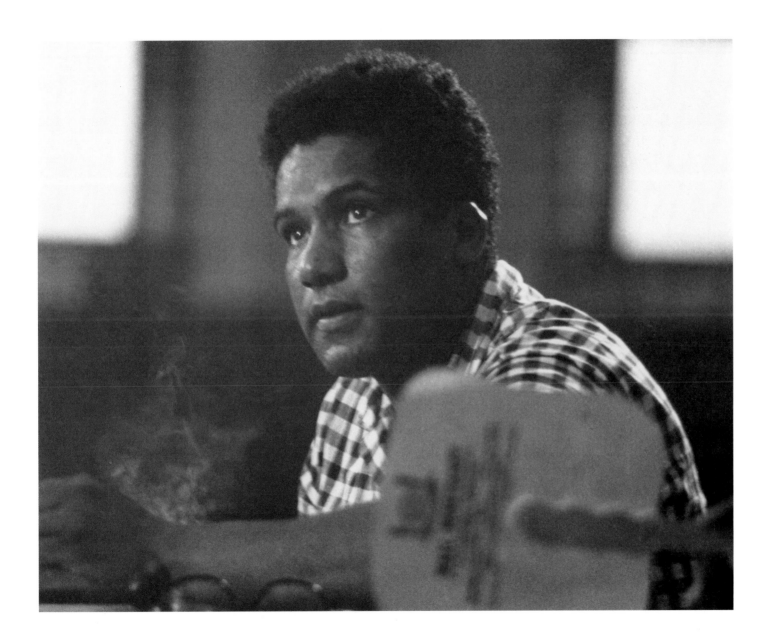

SNCC executive secretary James Forman

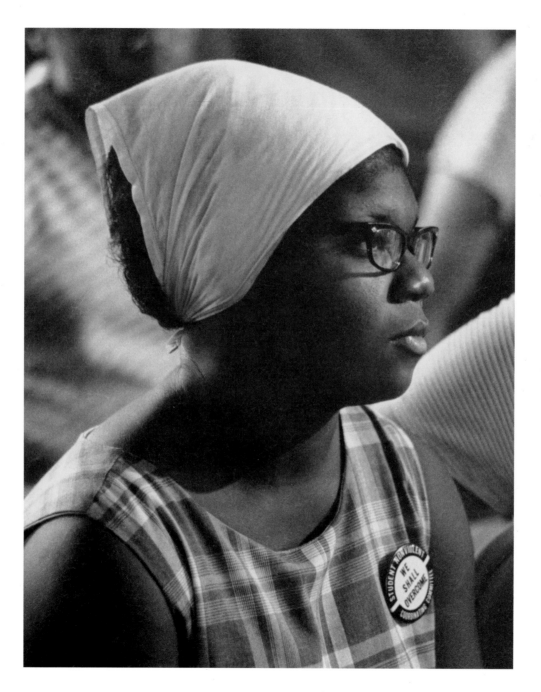

Mississippi Freedom Democratic
Party Fifth Congressional District
caucus

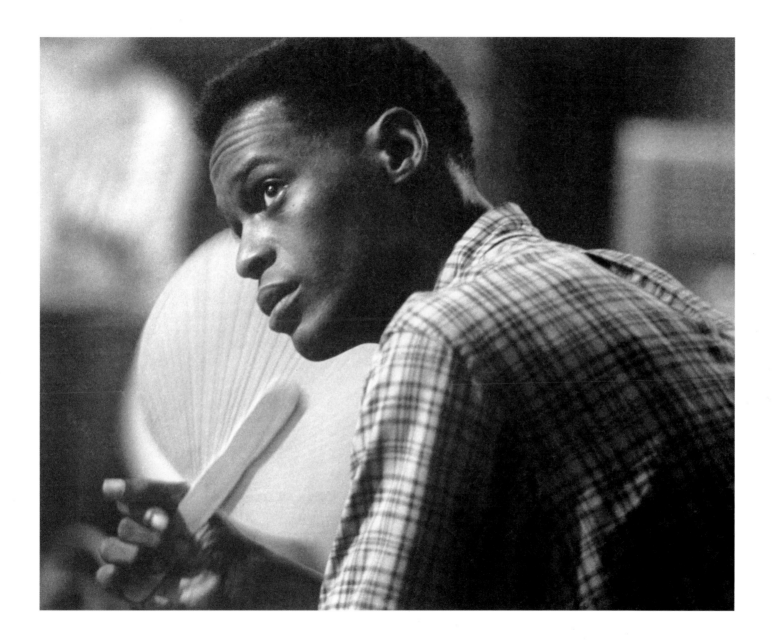

Sandy Leigh

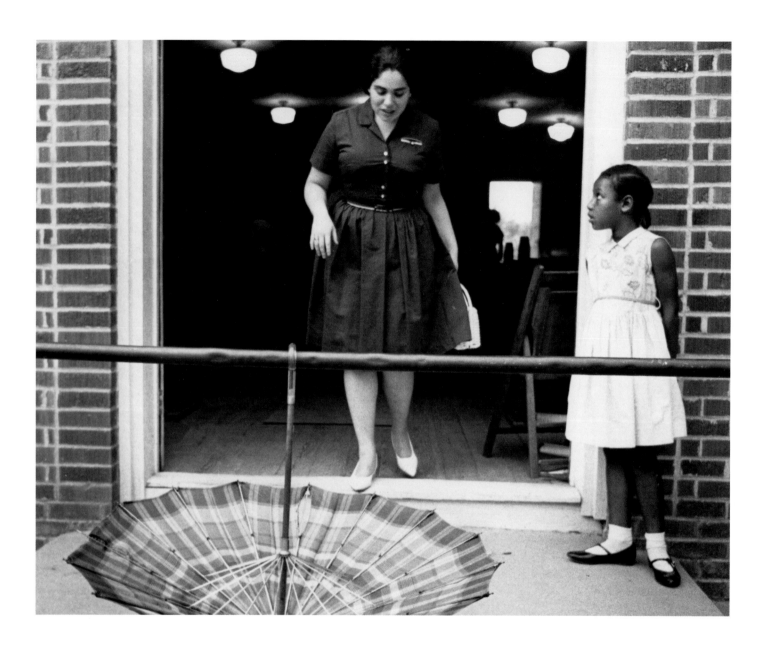

Volunteer Barbara Schwartzbaum (New York) and a child at entrance
to St. John United Methodist Church in Palmer's Crossing

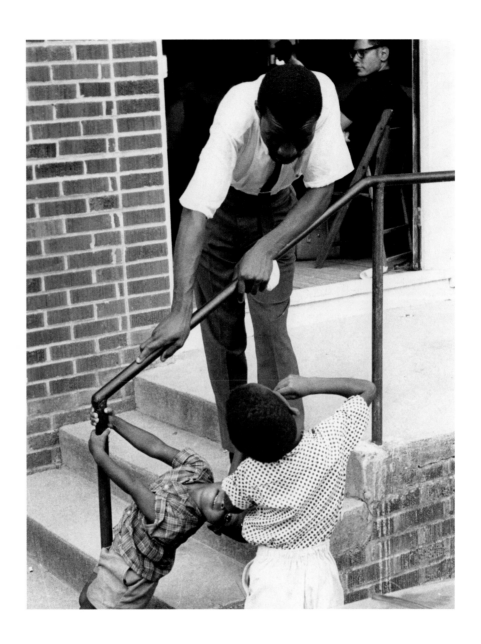

Volunteer William D. Jones and children at St. John United
Methodist Church

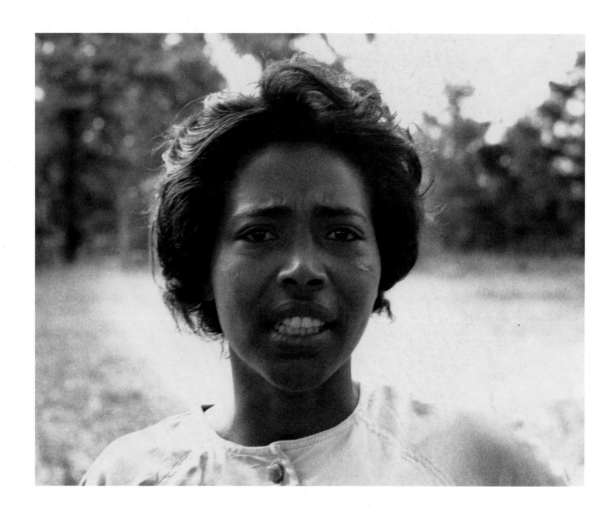

Victoria Jackson Gray

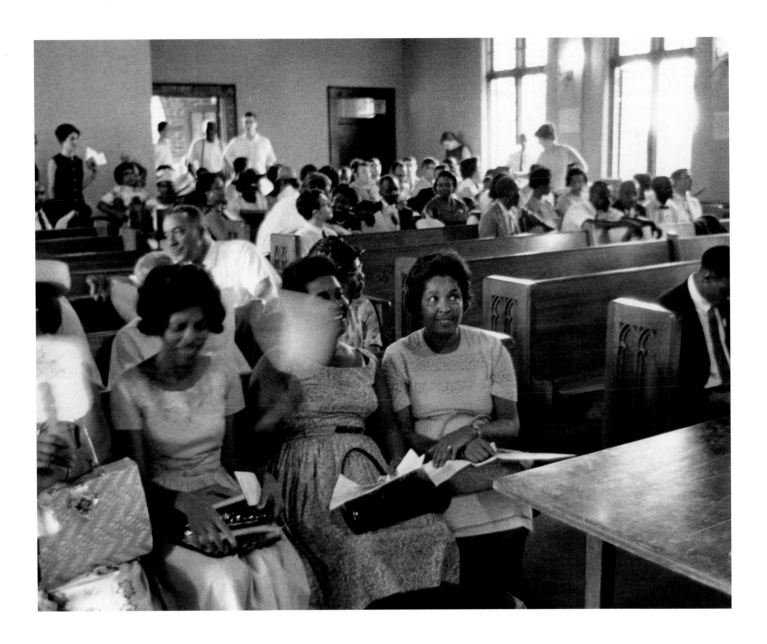

Mississippi Freedom Democratic Party Fifth Congressional District caucus at St. Paul United Methodist Church in Hattiesburg. Front row from left: local activists Peggy Jean Connor, Marie Blalock, and Helen Anderson.

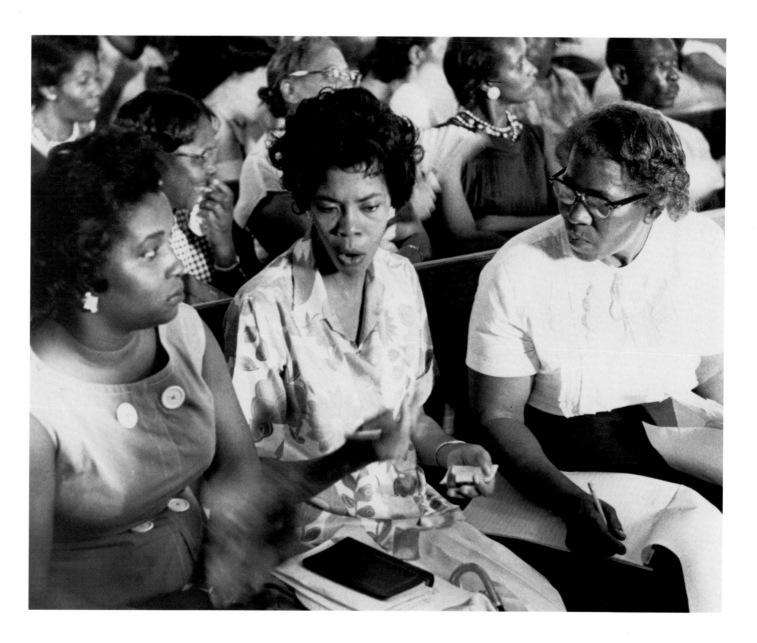

Mississippi Freedom Democratic Party Fifth Congressional District caucus. Front row from left: local activists Marie Blalock, Peggy Jean Connor, and Vassie Patton.

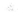

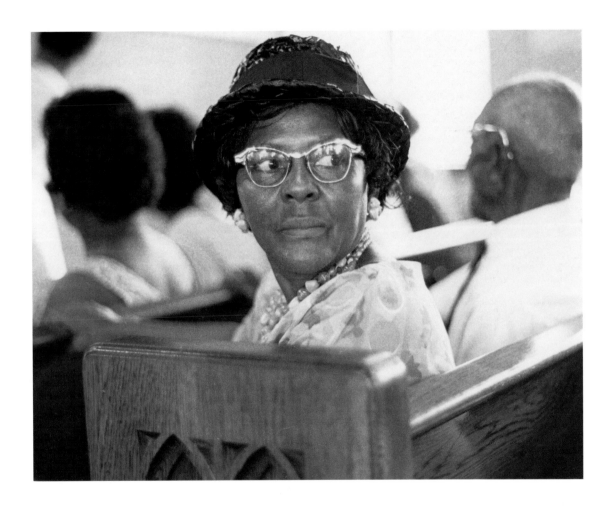

Ceola Wallace (Hattiesburg) at the Mississippi Freedom Democratic Party Fifth Congressional District caucus

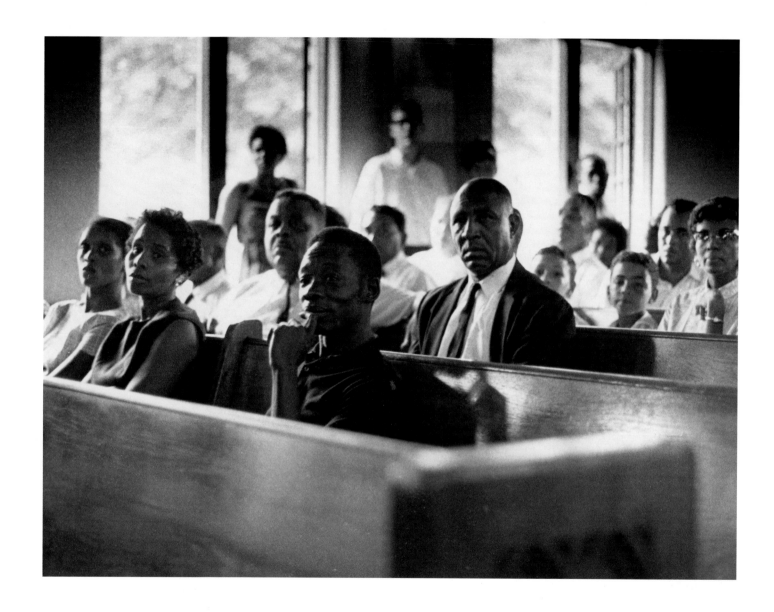

Mississippi Freedom Democratic Party Fifth Congressional
District caucus. Pictured are Rev. L. P. Ponder and, behind
him, Daisy Harris with her two sons, Anthony and James.

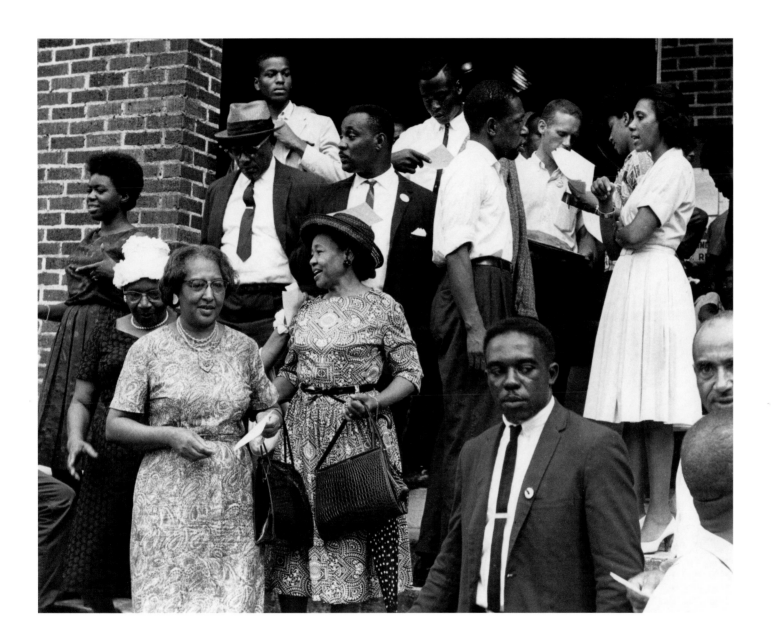

Volunteers, local residents, and COFO staff leaving St. Paul United
Methodist Church after a caucus

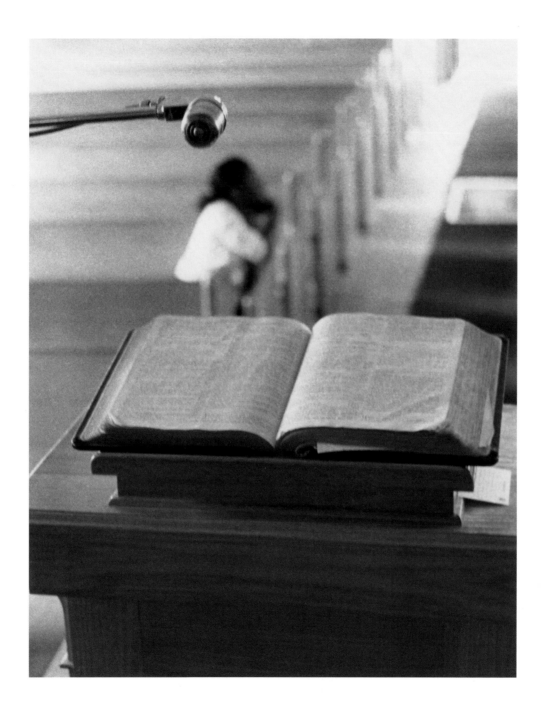

Open Bible in a Mississippi church

NOTES

1. John Lewis in James Atwater, "'If We Can Crack Mississippi . . . ,'" *Saturday Evening Post,* July 25–August 1, 1964, p. 19.

2. Esther Raushenbush, *John Hay Whitney Foundation: A Report of the First Twenty-Five Years,* vol. 1 (New York: John Hay Whitney Foundation, 1972), xv.

3. "Poet, Dancer, Painter—Fifty-six Grants," *New York Herald Tribune,* June 22, 1964, p. 7.

4. Sheila Michaels, COFO project manager in Hattiesburg, to Tusa, November 10, 1997. Statements by Michaels quoted in text below come from e-mail messages dating from November 9, 1997, through October 14, 1998.

5. Neil McMillen, "Black Enfranchisement in Mississippi," 351–52.

6. Ibid., 354.

7. SNCC, "Statement of Purpose," in *Nonviolence in America: A Documentary History,* ed. Staughton Lynd (Indianapolis: Bobbs-Merrill, 1966), 398–99.

8. Anne Moody, *Coming of Age in Mississippi* (New York: Dell, 1968), 252.

9. COFO, "Outline of Mississippi Project Areas," State Sovereignty Commission Series, Johnson Family Papers, McCain Library and Archives (USM Archives), University Libraries, University of Southern Mississippi.

10. COFO, "Prospectus for the Summer," State Sovereignty Commission Series, Johnson Family Papers, USM Archives.

11. Danny Lyon, *Memories of the Southern Civil Rights Movement,* 130–34.

12. Taylor Branch, *Pillar of Fire,* 217.

13. Luther Seabrook, Hattiesburg Freedom School teacher, telephone conversation with Tusa, January 27, 1998.

14. Zinn, *SNCC: The New Abolitionists,* 102–3.

15. William D. McCain, in Silver, *Mississippi,* 320.

16. Dick Kelly, in "Freedom Fighters Reunite," *Hattiesburg American,* June 26, 1994, p. 1B.

17. Luther Seabrook, telephone conversation with Tusa, January 27, 1998.

18. Zinn, *SNCC: The New Abolitionists,* 103.

19. State Sovereignty Commission, "Special Report, July 21, 1964," State Sovereignty Commission Series, Johnson Family Papers, USM Archives.

20. Silver, *Mississippi.*

21. [David Owen], in Martinez, *Letters from Mississippi,* 123.

22. [Lawrence Spears], in Martinez, *Letters from Mississippi,* 123.

23. State Sovereignty Commission, "Special Report on Forrest County, July 8, 1964," State Sovereignty Commission Series, Johnson Family Papers, USM Archives.

24. Teela Lelyveld, telephone conversation with Tusa, June 9, 1998.

25. Mississippi Summer Project, Running Summary of Incidents, June 16–July 16, 1964, in *The Student Nonviolent Coordinating Committee Papers, 1959–1972,* microfilm (Ann Arbor: UMI, 1994), reel 69.

26. Staughton Lynd, in Holt, *The Summer That Didn't End,* 318.

27. "Second Session of Freedom Schools to Begin on July 29," Palmer's Crossing Freedom Schools *Freedom News,* no. 1 (July 25, 1964), 6. Copy in Sandra Adickes Papers, USM Archives.

28. Sandra Adickes, "The Legacy of the Mississippi Freedom Schools," *Radical Teacher,* no. 44 (n.d.), 10. Copy in Sandra Adickes Papers, USM Archives.

29. Ibid.

30. COFO, "Notes on Teaching in Mississippi," in Holt, *The Summer That Didn't End*, 324–25.

31. Freedom School Students of St. John United Methodist Church (Palmer's Crossing), "Declaration of Independence," *Freedom News*, no. 1 (July 25, 1964), [7]. Copy in Sandra Adickes Papers, USM Archives.

32. Liz Fusco, "Freedom Schools in Mississippi, 1964," Vertical File "Civil Rights," Mississippiana Collection, McCain Library and Archives, USM.

33. Parker, *Turning Point*, 6.

34. McMillen, "Black Enfranchisement in Mississippi," 367.

35. J. C. Fairley, in "Civil Rights Leader Recalls Struggle," *Hattiesburg American*, February 27, 1994, p. 1A.

36. Victoria Gray Adams, in "Volunteers Risked Lives in Fight for Equality," *Hattiesburg American*, August 28, 1994, p. 12A.

BIBLIOGRAPHY

Manuscript Collections in the USM Archives

Victoria Gray Adams Papers

Sandra E. Adickes Papers

Fay Botnick Civil Rights Collection

Raylawni Branch Collection

Will D. Campbell Papers

Citizens' Council / Civil Rights Collection (Neil McMillen)

Civil Rights in Mississippi Collection

Peggy Jean Connor Papers

Crawford Company Civil Rights Letter

Vernon F. Dahmer Collection

William F. Dukes F.B.I. Scrapbook

P. D. East Collection

Joseph and Nancy Ellin Freedom Summer Collection

J. C. Fairley Civil Rights Collection

FBI File: MIBURN (Mississippi Burning) microform

FBI File: investigation of the murders of Michael Schwerner, James Chaney, and Andrew Goodman in Neshoba County, Mississippi, June 21, 1964, microform

FBI File: Student Nonviolent Coordinating Committee microform

Glenda Funchess Civil Rights Collection

Jinny Glass Mississippi Freedom Summer Diary

Jill Wakeman Goodman Civil Rights Collection

W. G. "Bud" Gray Papers

Ira Grupper and Bob Beech Civil Rights Collection

Anthony J. Harris Civil Rights Memoir

Jackson Freedom House Civil Rights Photograph

Paul B. Johnson Family Papers

Erle E. Johnston, Jr., Papers

Erle Johnston Oral History Appendix

Robert F. Kennedy Civil Rights Letter

Lucy Komisar Civil Rights Collection

Umoja Kwanguvu Freedom Summer Collection

Rabbi Arthur J. Lelyveld Collection

Will Mack Hanging Photographs

Rabbi Charles Mantinband Papers

William D. McCain Collection

Sheila Michaels Papers

Charles Moore Civil Rights Photograph Portfolio

Oral history interviews with civil rights leaders recorded by the USM Oral History Department

Mamie L. Phillips Civil Rights Memoir

Herbert Randall Freedom Summer Photographs

Stephen C. Rose Papers

Myrtis Rue African American Hattiesburg Collection

Ben Shahn Lithographs

Terri Shaw Freedom Summer Collection

Lawrence D. Spears Civil Rights Collection

Peter Stoner Papers

Student Nonviolent Coordinating Committee Papers microform

Daisy Harris Wade Papers

George C. Wallace Speeches

Zoya Zeman Freedom Summer Collection

Books, Theses, and Articles

Belfrage, Sally. *Freedom Summer.* New York: Viking Press, 1965.

Branch, Taylor. *Pillar of Fire: America in the King Years, 1963–65.* New York: Simon & Schuster, 1998.

Burson, George S. "The 1964 Mississippi Freedom Summer Project." M.A. Thesis, University of Southern Mississippi, 1972.

Carson, Clayborne. *In Struggle: SNCC and the Black Awakening of the 1960s.* Cambridge, Mass.: Harvard University Press, 1981.

Dent, Thomas C., et al. *The Free Southern Theater by the Free Southern Theater.* Indianapolis: Bobbs-Merrill, 1969.

Dittmer, John. *Local People: The Struggle for Civil Rights in Mississippi.* Urbana: University of Illinois Press, 1994.

Holt, Len. *The Summer That Didn't End.* New York: William Morrow, 1965.

Loewen, James W., and Charles Sallis, eds. *Mississippi: Conflict and Change.* New York: Random House, 1974.

Lyon, Danny. *Memories of the Southern Civil Rights Movement.* Chapel Hill: University of North Carolina Press, 1992.

Martinez, Elizabeth Sutherland. *Letters from Mississippi.* New York: McGraw-Hill, 1965.

McAdam, Doug. *Freedom Summer.* New York: Oxford University Press, 1988.

McCarty, Kenneth G., Jr. *Hattiesburg: A Pictorial History.* Jackson: University Press of Mississippi, 1982.

McCord, William Maxwell. *Mississippi: The Long, Hot Summer.* New York: W. W. Norton, 1965.

McMillen, Neil. "Black Enfranchisement in Mississippi: Federal Enforcement and Black Protest in the 1960's." *Journal of Southern History,* 43 (August 1977), 351–72.

———. *Dark Journey: Black Mississippians in the Age of Jim Crow.* Urbana: University of Illinois Press, 1989.

Mills, Nicolaus. *Like a Holy Crusade: Mississippi, 1964.* Chicago: I. R. Dee, 1992.

Mississippi Black Paper. Introduced by Hodding Carter. New York: Random House, 1965.

Mississippi Homecoming 1994: Freedom Summer 1964 Revisited. Jackson: Mississippi Community Foundation, 1994.

Parker, Frank R. *Turning Point: The 1964 Mississippi Freedom Summer.* Washington, D.C.: Joint Center for Political and Economic Studies, 1994.

Payne, Charles M. *I've Got the Light of Freedom: The Organizing Tradition and the Mississippi Freedom Struggle.* Berkeley: University of California Press, 1995.

Pearlstein, Daniel. "Teaching Freedom: SNCC and the Creation of the Mississippi Freedom Schools." *History of Education Quarterly,* 30 (Fall 1990), 297–324.

Rothschild, Mary Aickin. *A Case of Black and White: Northern Volunteers and the Southern Freedom Summers, 1964–1965.* Westport, Conn.: Greenwood Press, 1982.

Silver, James. *Mississippi: The Closed Society.* Rev. ed. New York: Harcourt, Brace & World, 1966.

Tucker, Shirley. *Mississippi from Within.* New York: Arco, 1965.

Tusa, Bobs M. "How the Civil Rights Movement Came to the Hattiesburg Public Library." Mississippi Libraries 62 (Fall 1998), 56–57.

Zinn, Howard. "Schools in Context: The Mississippi Idea." *Nation,* November 23, 1964, pp. 371–75.

———. *SNCC: The New Abolitionists.* Boston: Beacon Press, 1964.

———. *You Can't Be Neutral on a Moving Train.* Boston: Beacon Press, 1994.

INDEX

HERBERT RANDALL is a past recipient of the John Hay Whitney Fellowship for Creative Photography and the Creative Artists Public Service Grant for Photography. His photographs are represented in the permanent collections of the Metropolitan Museum of Art, the Museum of Modern Art, the IBM Collection, the Charles Rand–Penney Foundation, the International Museum of Photography, the Library of Congress, the New York Public Library, and the Vassar College Art Gallery. He resides in Southampton, New York.

BOBS M. TUSA is University Archivist at the University of Southern Mississippi in Hattiesburg, Mississippi. She received her bachelor of arts degree from Baylor University, a doctorate from Tulane University, and a master of library science degree from the University of Alabama. She has written several articles on such varied topics as library archive materials, civil rights, and Latin American literature.